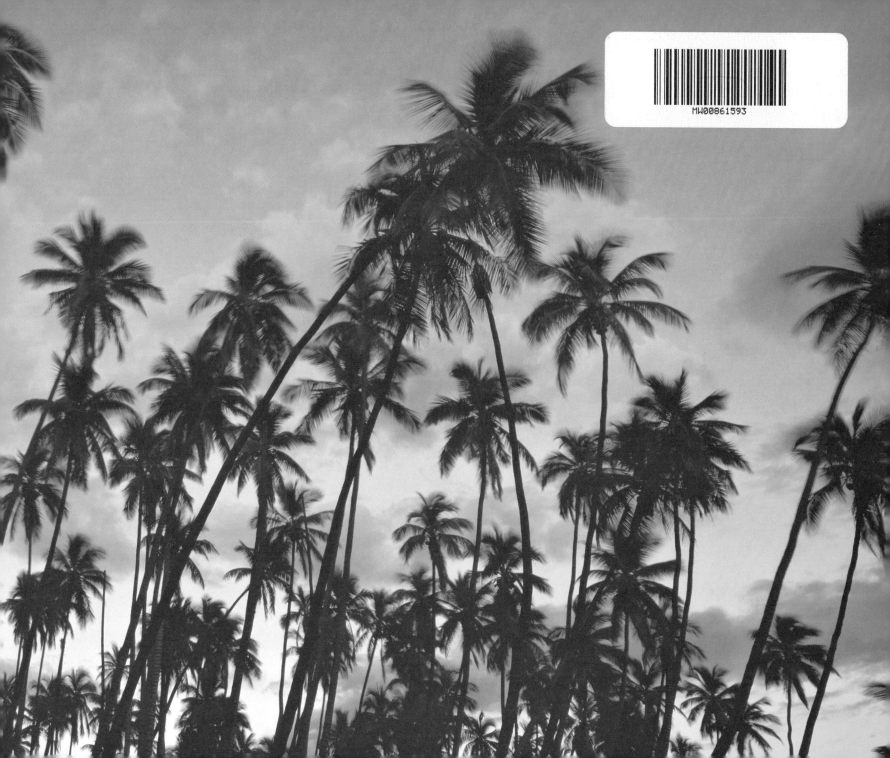

HAWAIIAN PARADISE

HAWAIIAN PARADISE

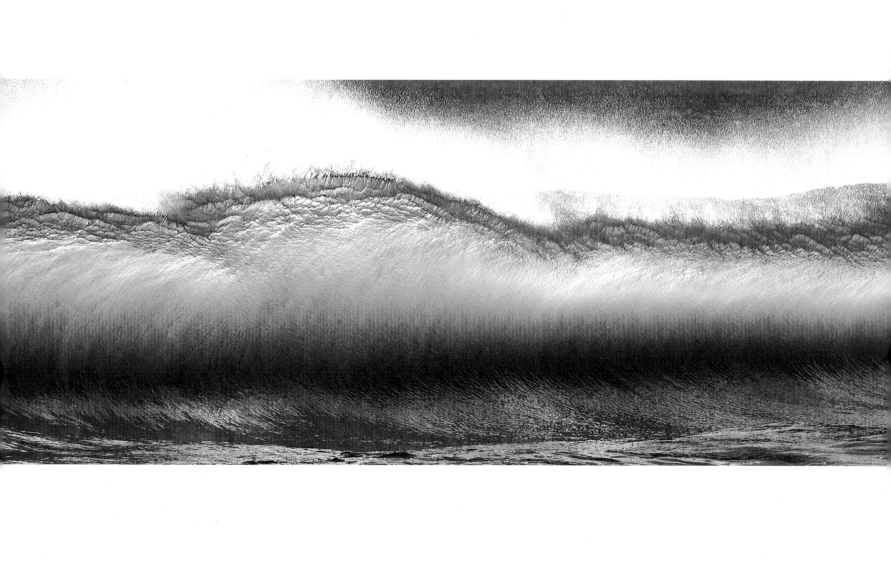

Maui

HAWAIIAN PARADISE

"Maui's spectacular landscape
has captured my spirit and keeps me coming back."

peter lik

From every challenge conquered, a new challenge arises. Although intensely proud of the results of my five year journey through the United States for the award-winning book 'Spirit of America', it just created another scratch which needed itching. I was haunted by the desire to return to the 50th state, Hawaii. From the moment we swooped over the cloudy peak of the awesome Haleakala volcano, I was hooked. I have returned again and again to the islands of Maui and Molokai, each trip, each kilometre, revealing a stunning display of nature, just waiting to be eternalized on film.

Maui and Molokai are just two of the six volcanic islands which make up the state of Hawaii. At just 728 square miles, Maui has to be one of the most ecologically diverse land masses on the planet. From the windswept sub-zero craters of Haleakala to the tropical paradise of the Pipiwai Trail, every extreme of temperature and every variety of landscape is represented. Each square mile has its own microclimate and the ever present peak of Haleakala wreaks havoc with normal weather patterns. I remember the first time I ascended the volcano, I left a scorching Lahaina, in t-shirt and sunnies, only to arrive at the peak, shivering with cold and dizzy from the effects of altitude. In fact I was so cold that I was forced to descend!

The road which circumnavigates Maui is one of the craziest I have ever experienced, treacherous switchbacks with treacherous single lanes carved into vertical cliffs and breathtaking views from every angle. The sheer cliffs of Molokai are inaccessible by road, I hitched a ride with a helicopter several times to access the remoter areas of the island. The rugged and utterly deserted coastline frequently gave me the exhilarating impression I was discovering uncharted territory.

Hawaiians are fiercely proud of their cultural heritage and every hilly outcrop and tumbling waterfall proudly bares its traditional place name. I found the Hawaiian language a bit tricky to get to grips with; with just 12 letters in the alphabet those vowels can be pretty difficult to string together! Asking for directions became an art, and following them even more so, resulting in some spectacular accidental discoveries. In the end, all roads lead to a photograph in Maui!

Following Page: The stunning natural aquarium of Molokini Crater, South Maui

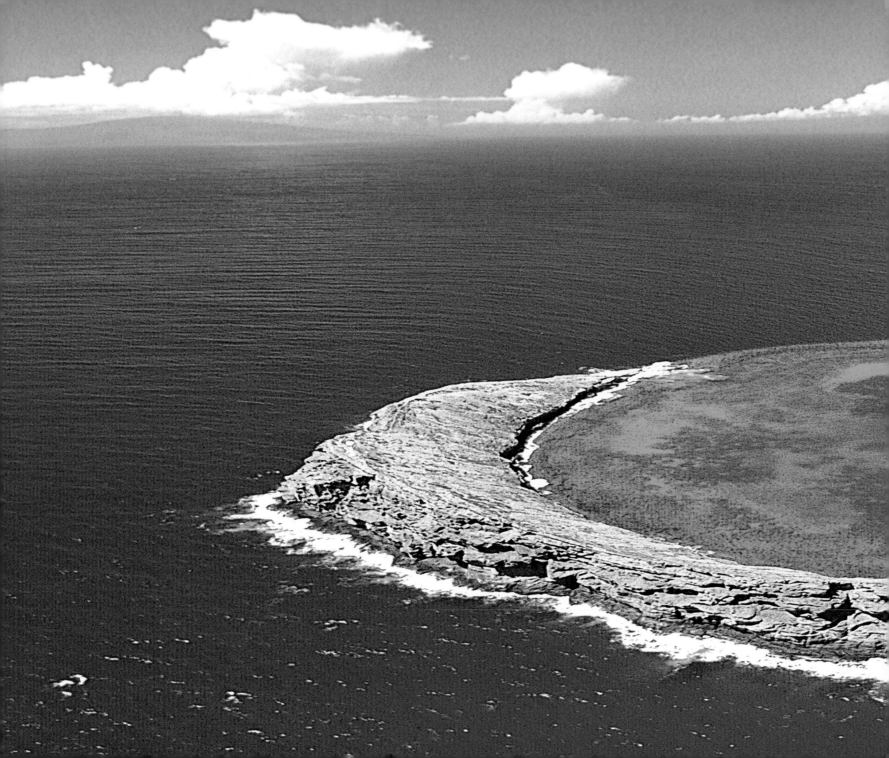

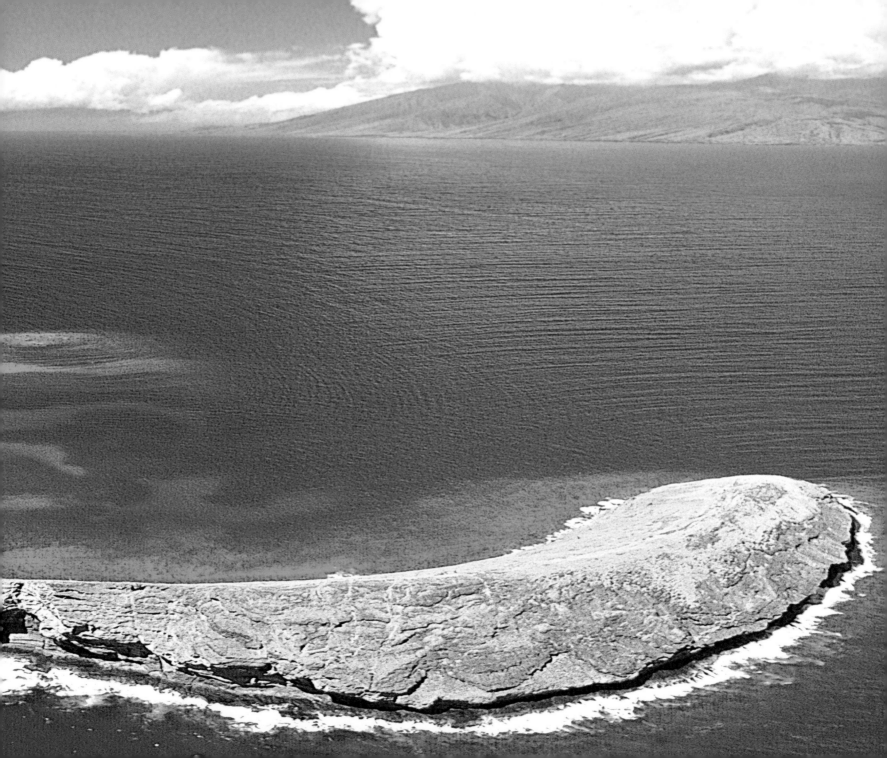

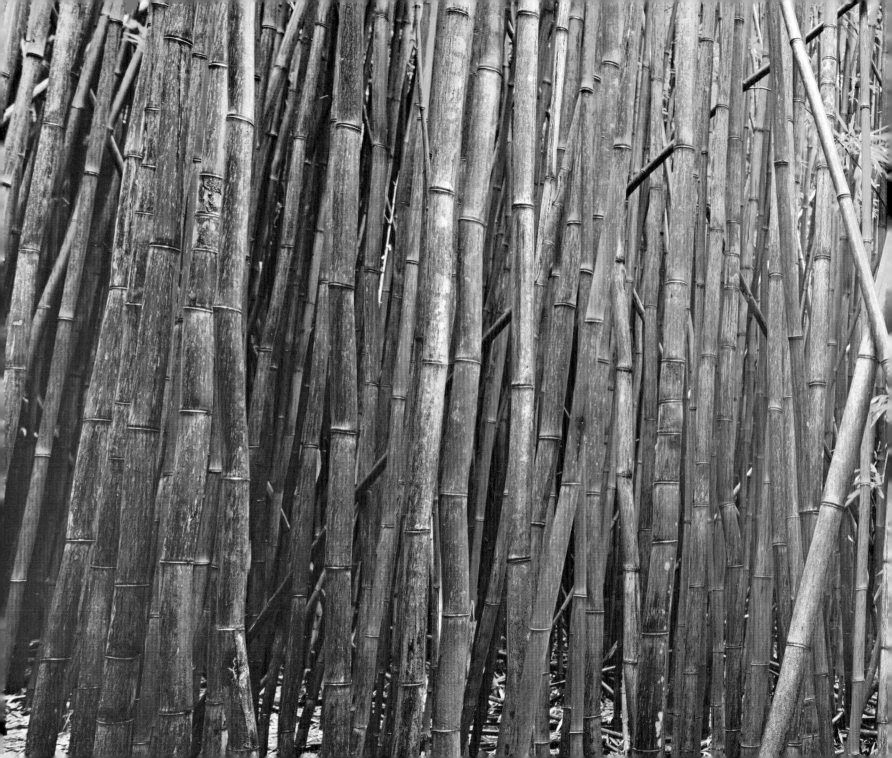

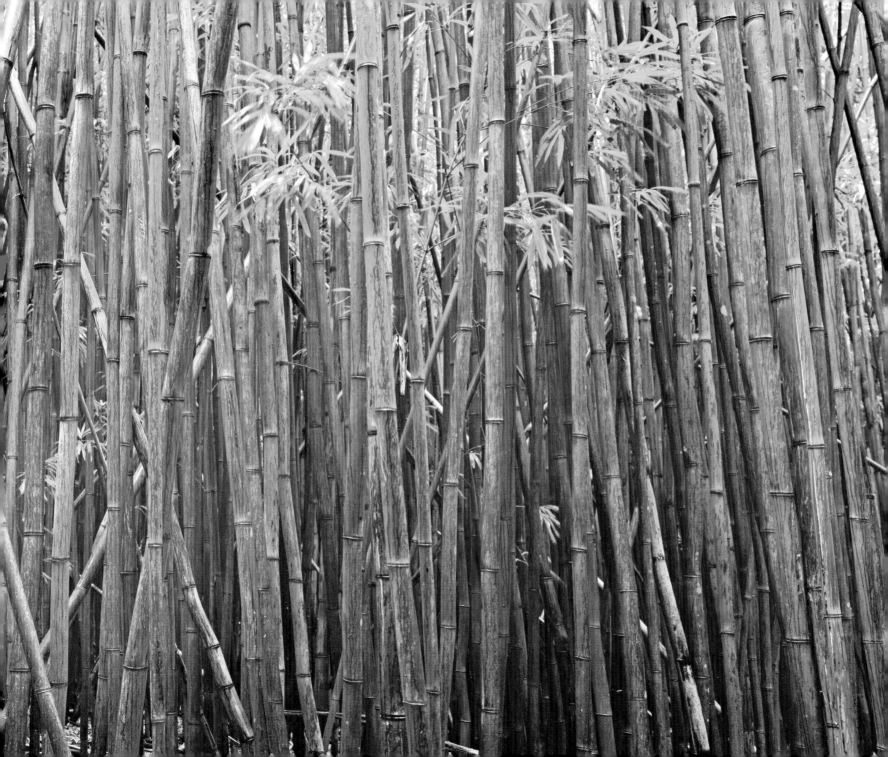

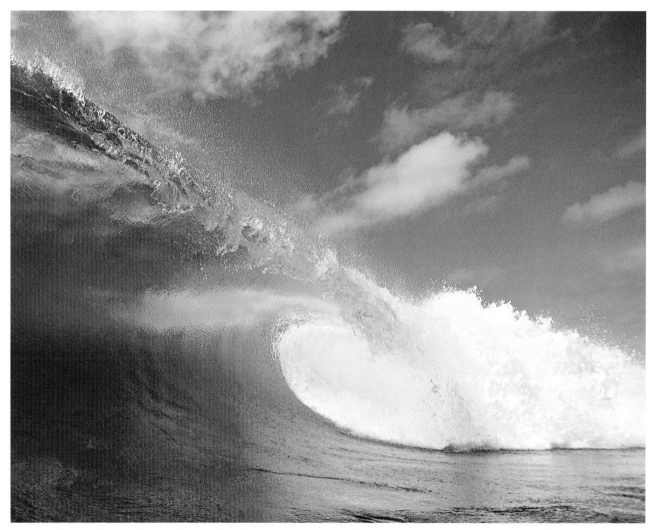

Previous Page: Bamboo Forest, Pipiwai Trail, Hana Opposite: The coastal road, travelling South from Lahaina

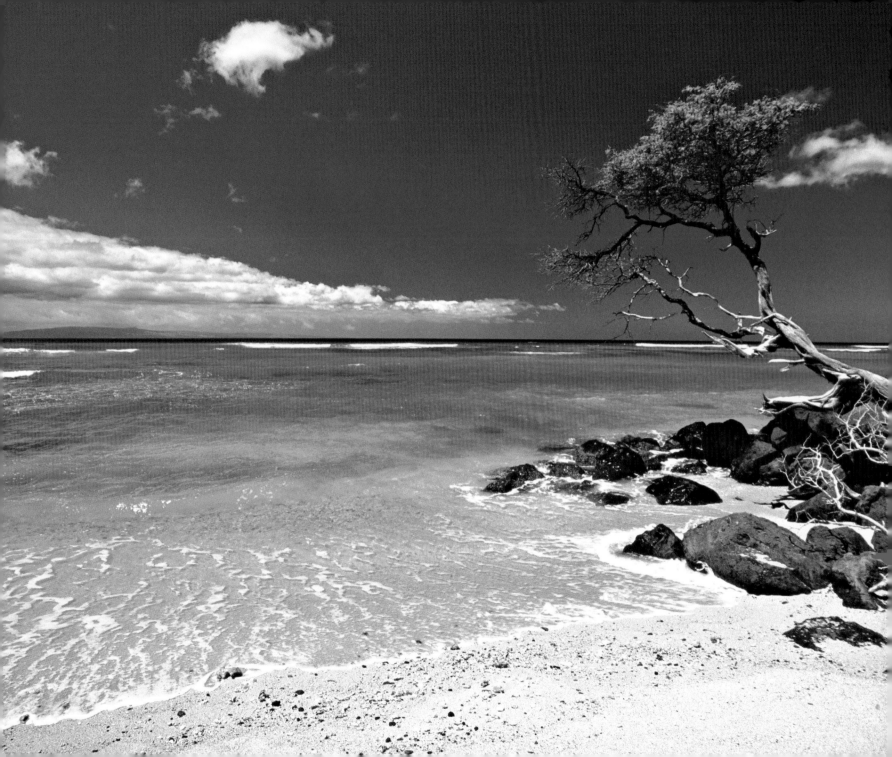

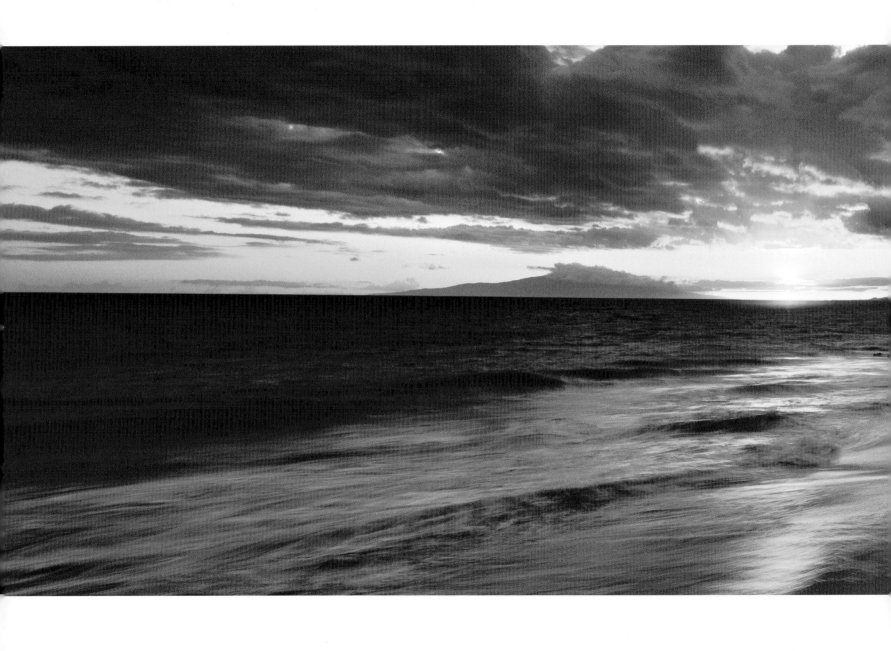

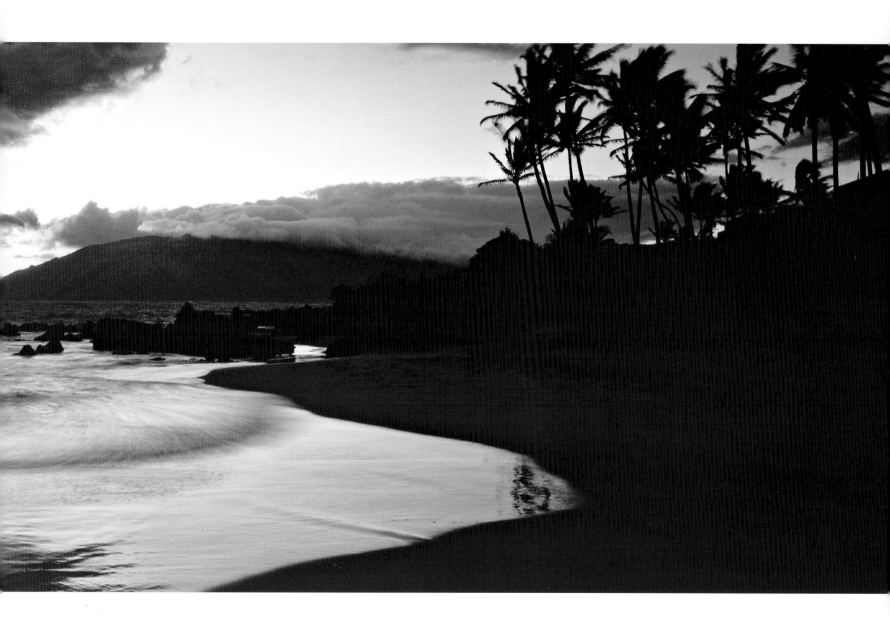

Majestic sunset at Kamaole Beach

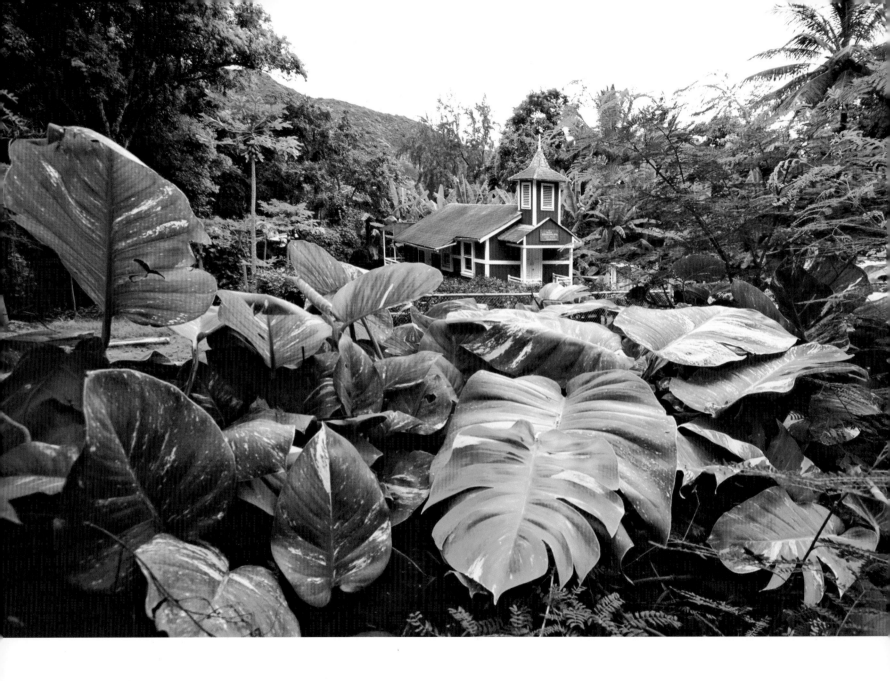

Rainforest church, Molokai

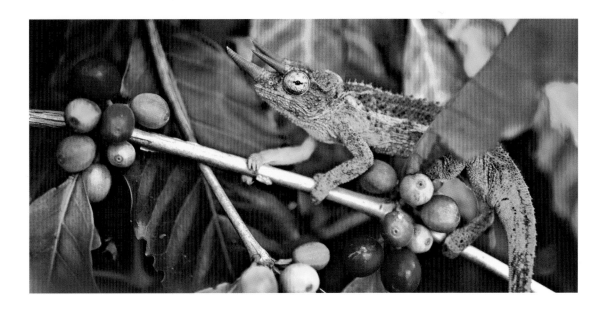

Maui is home to some exotic creatures. The 'Jackson's Chameleon' is no exception, with a tongue one and a half times its own body length and the ability to change its skin pigmentation at will. This little guy was doing his best impression of a leaf, totally ignoring me as I crept within centimetres to get this shot.

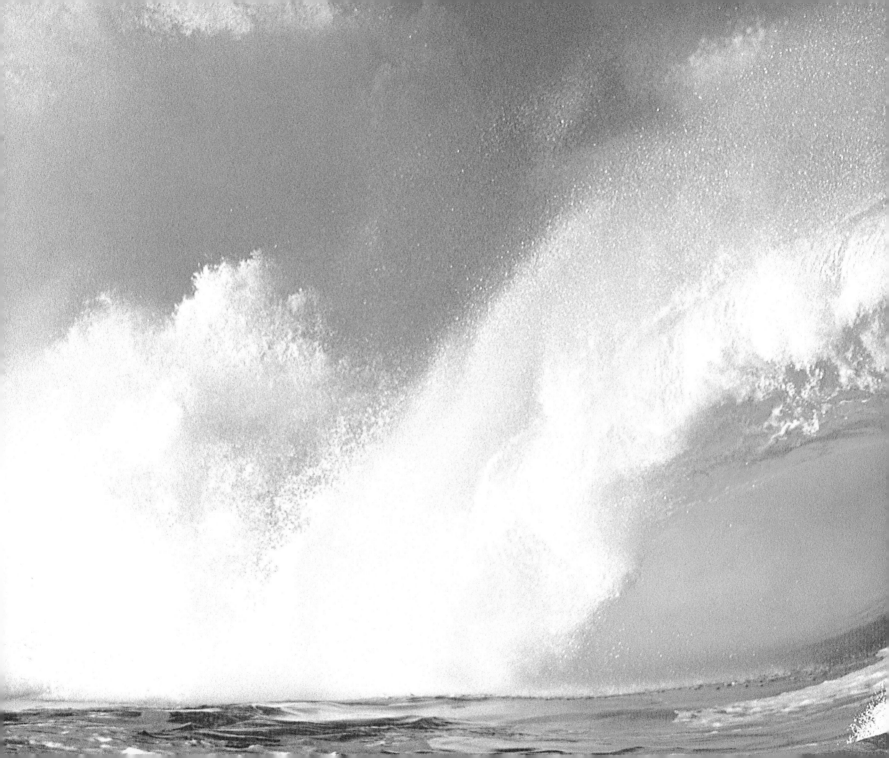

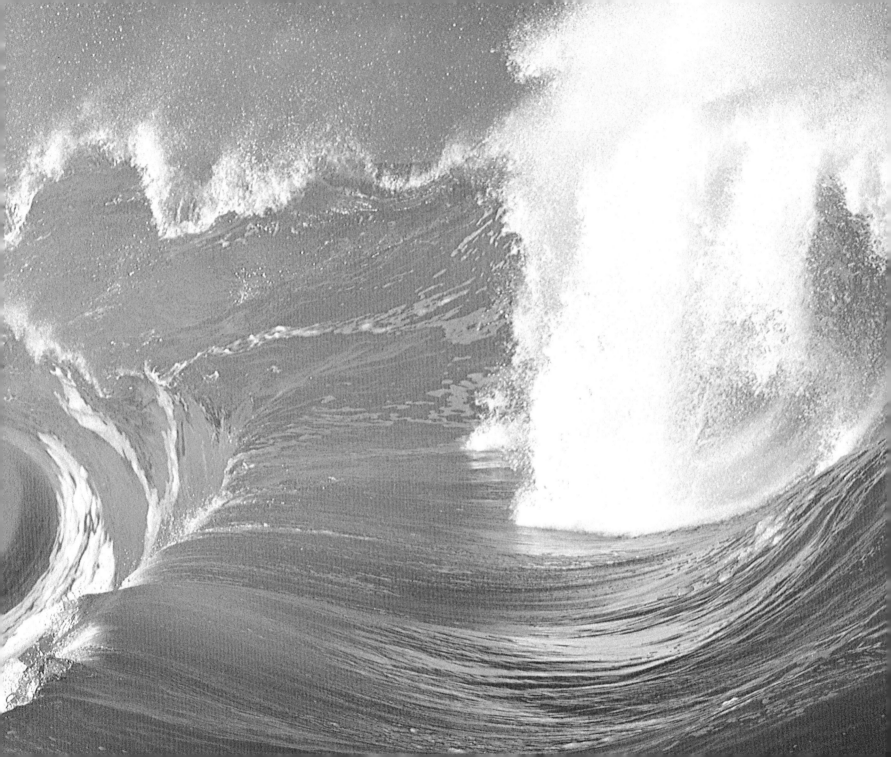

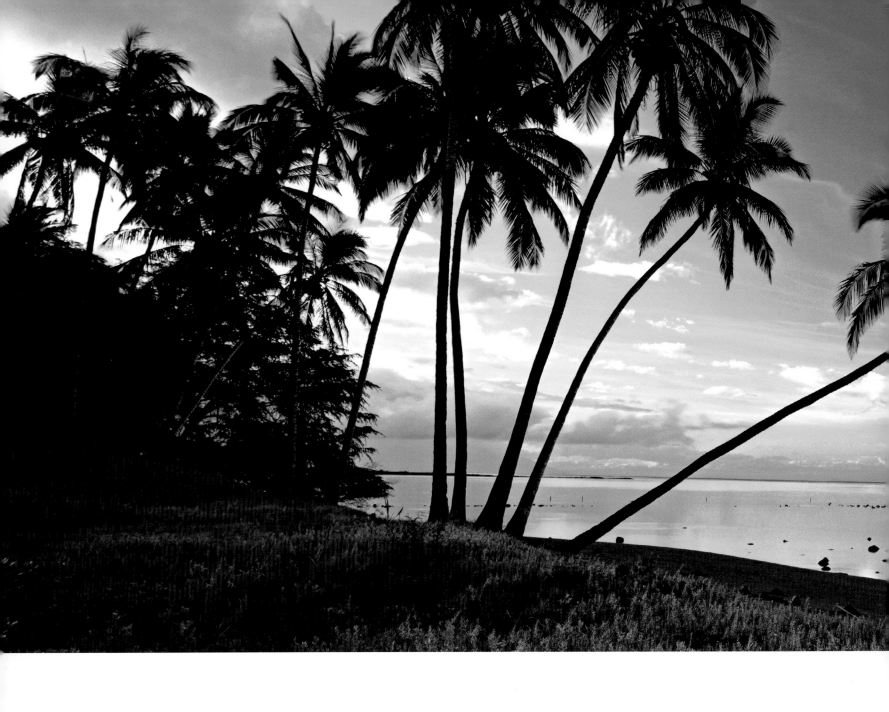

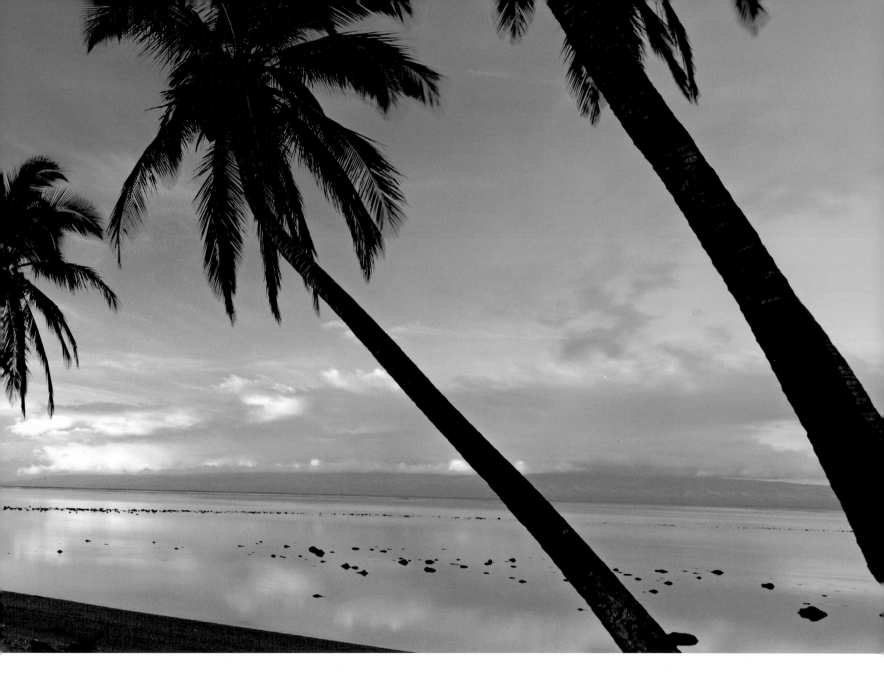

Sea of glass, morning reflections off Kaunakakai, Molokai

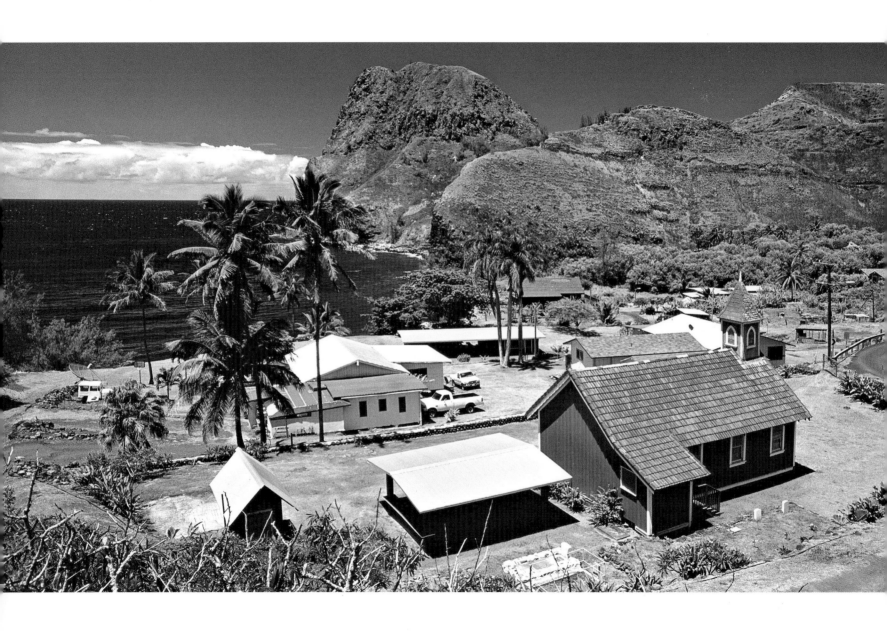

Traditional village life continues in the remote Kahakuloa Village

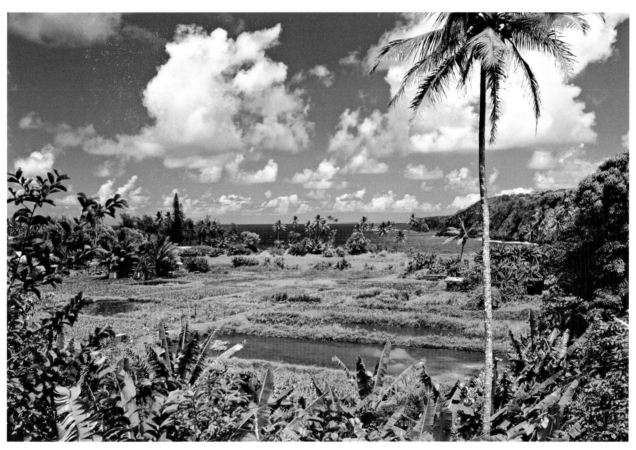

Taro fields of the Wailua farming community

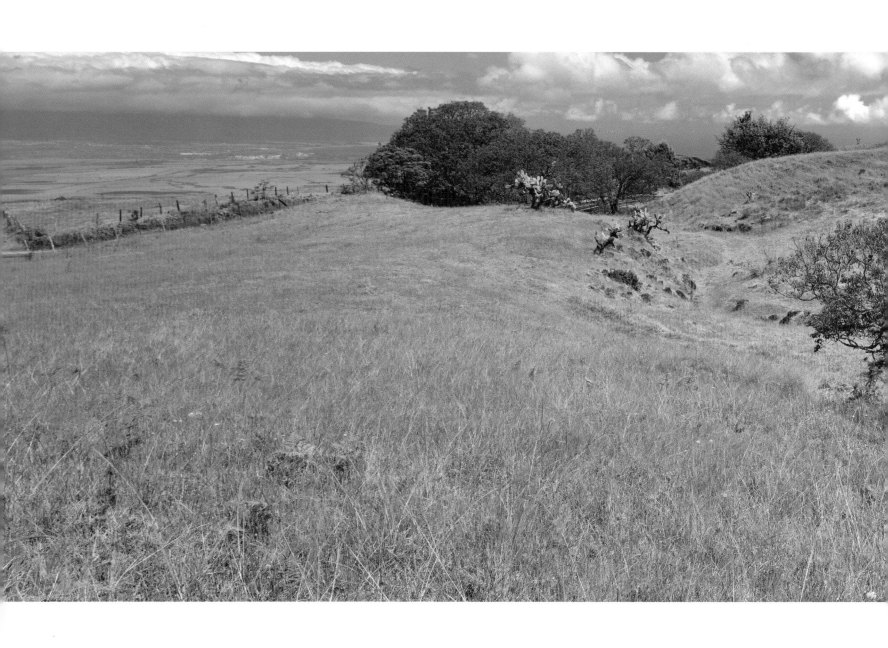

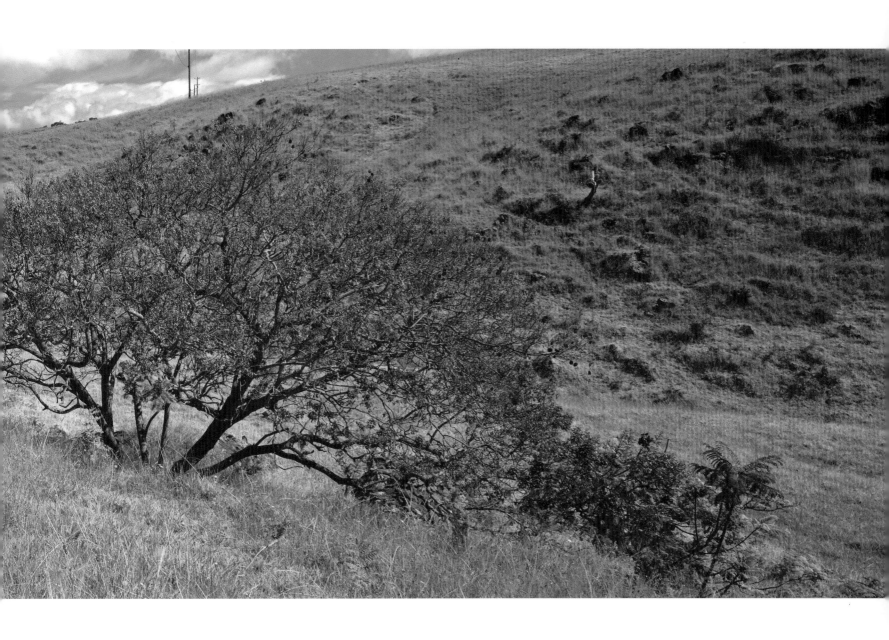

Jacaranda Trees provide a burst of color in 'upcountry' Kula

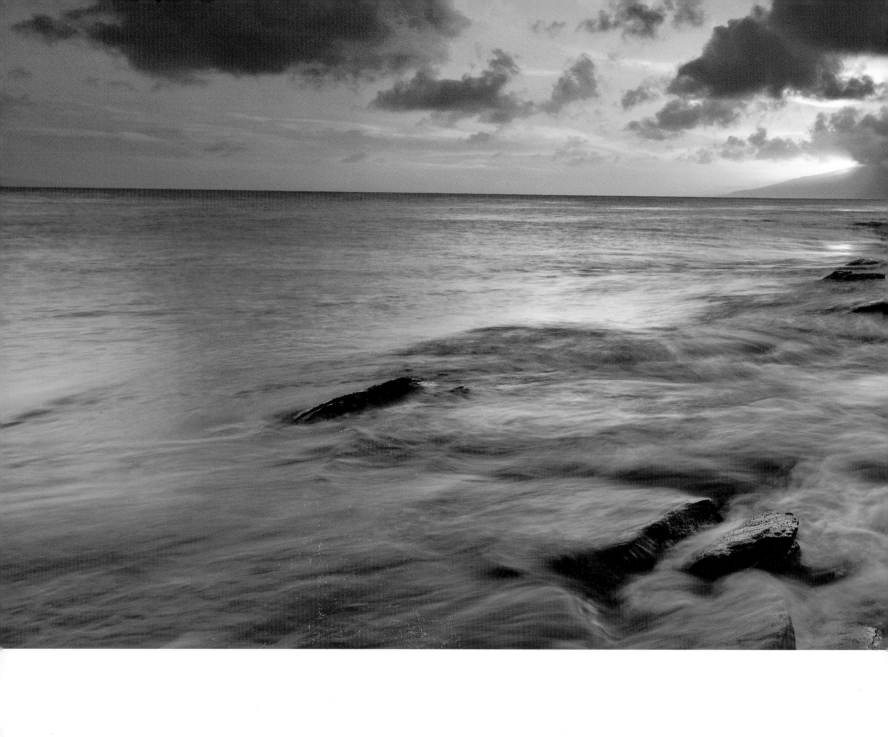

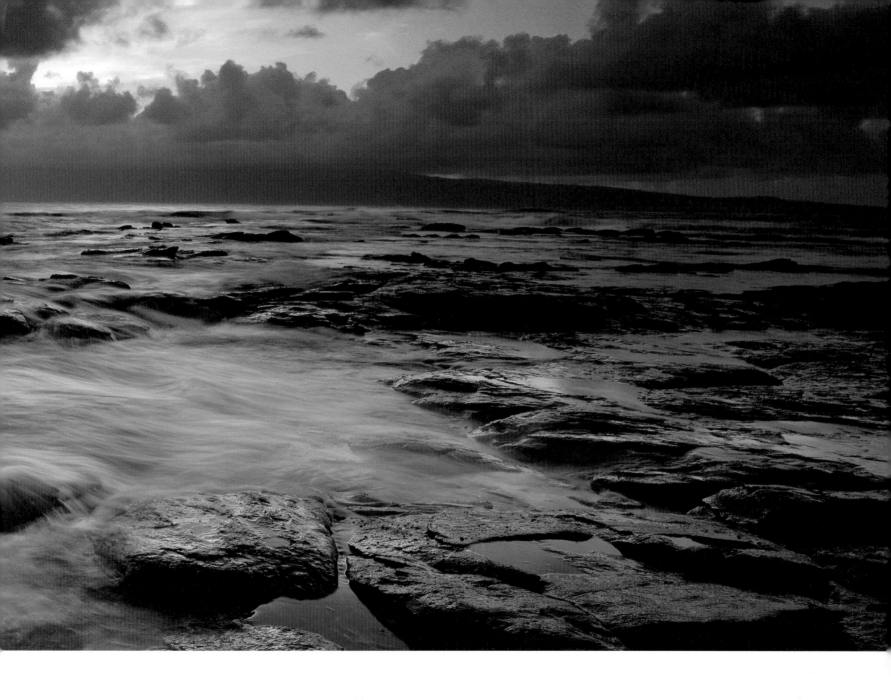

Mustering storm clouds, Kapalua

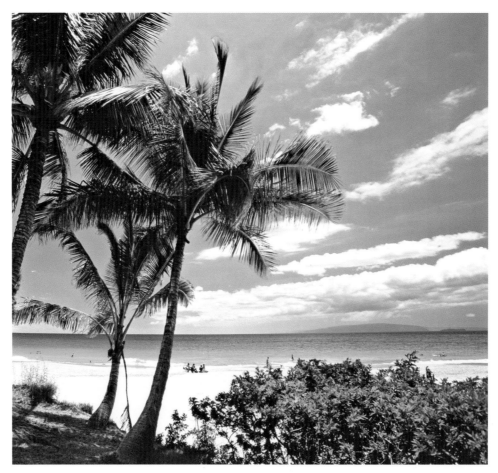

Tropical paradise at Kihei Beach

Overleaf: Rainbow Eucalyptus, Hana Highway

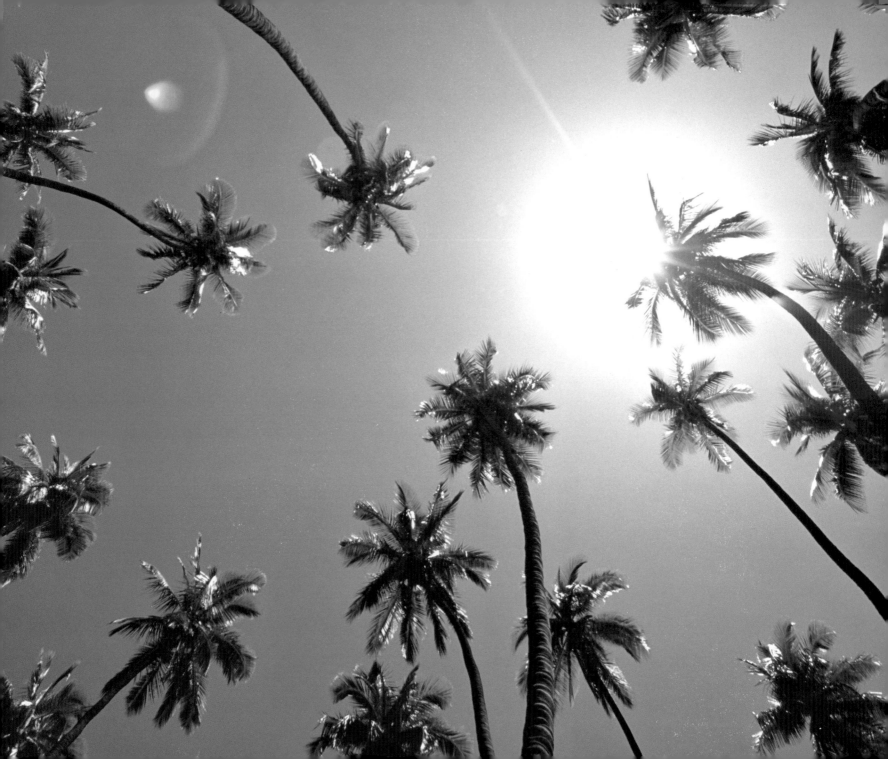

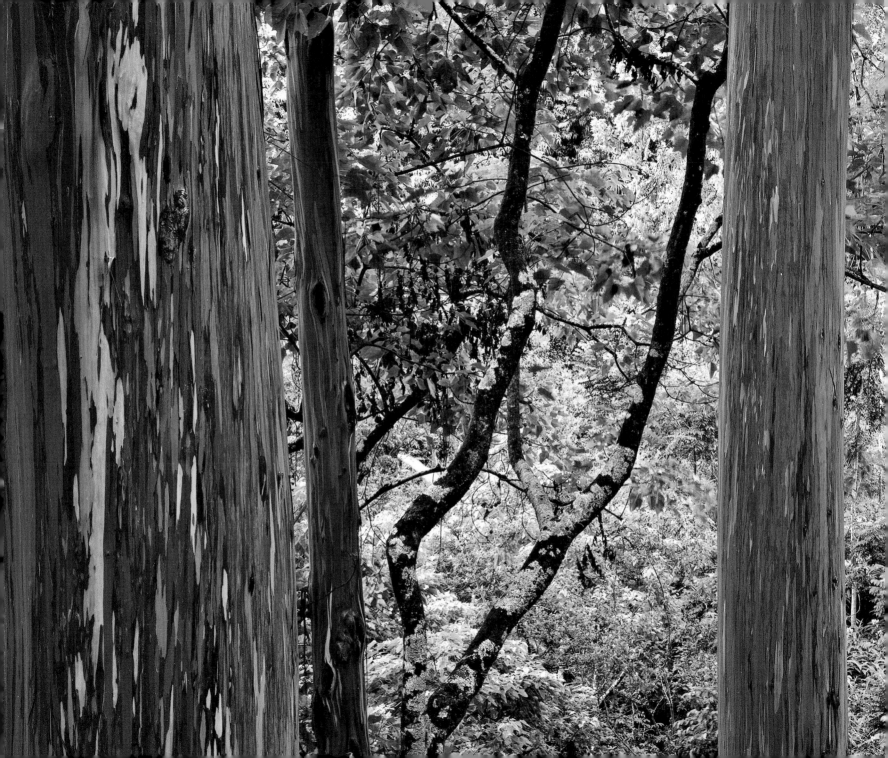

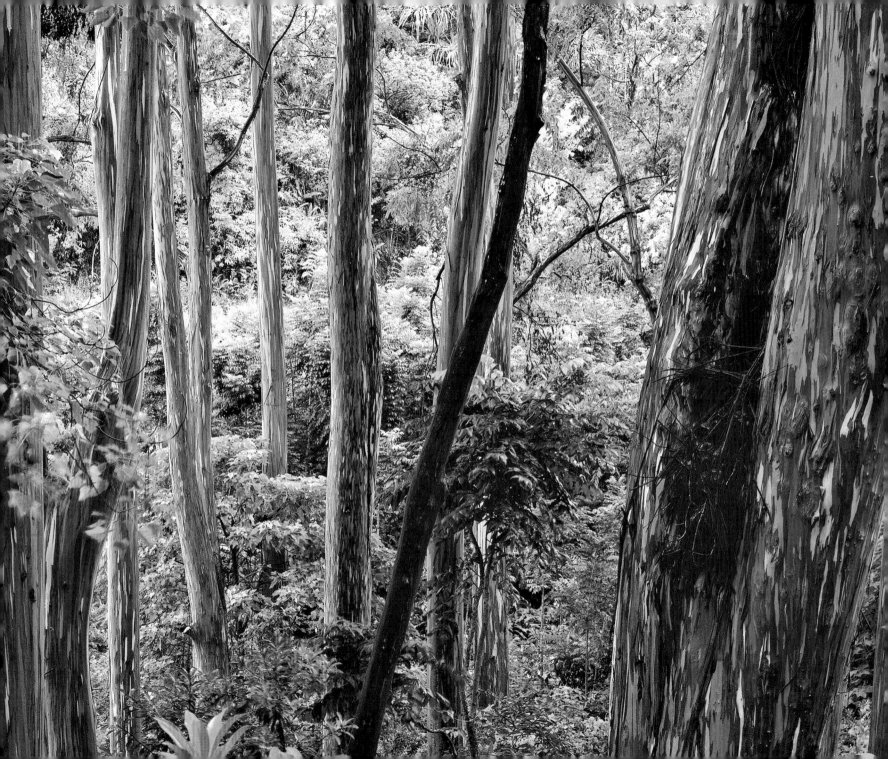

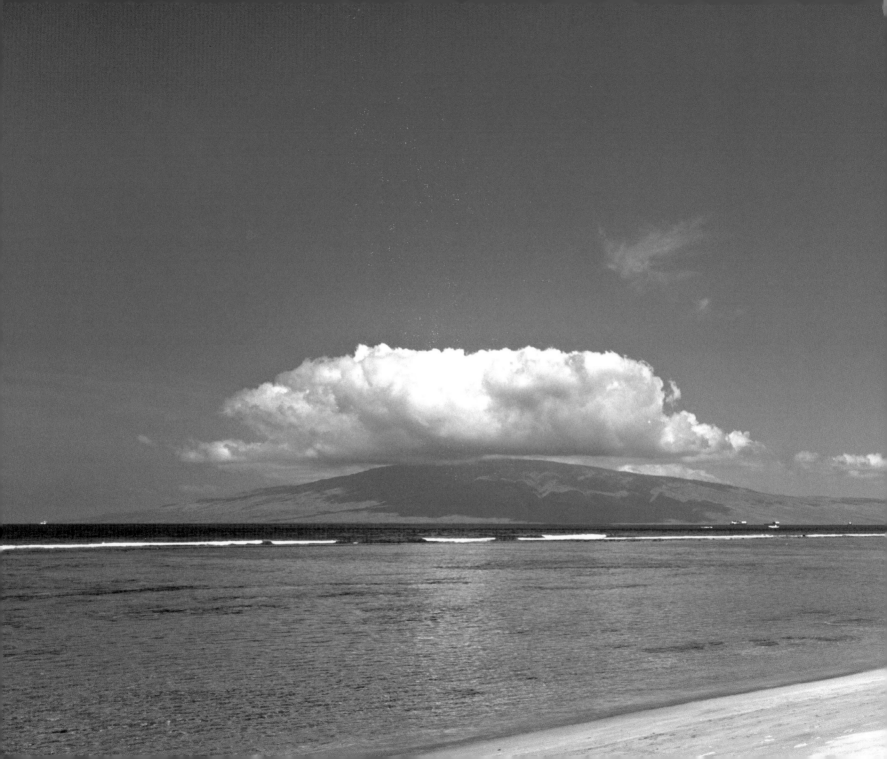

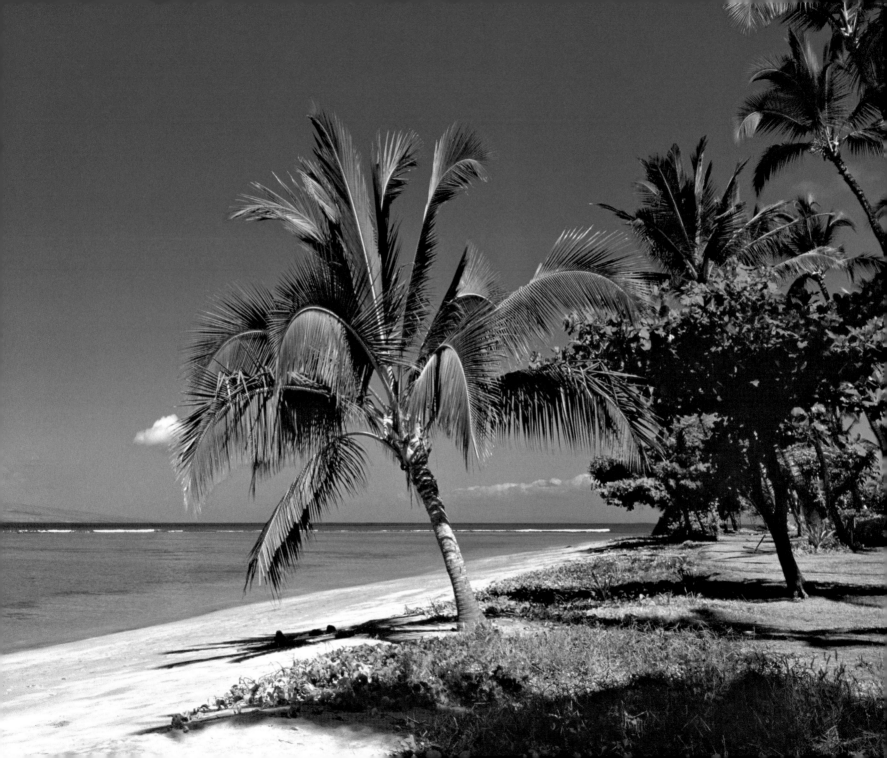

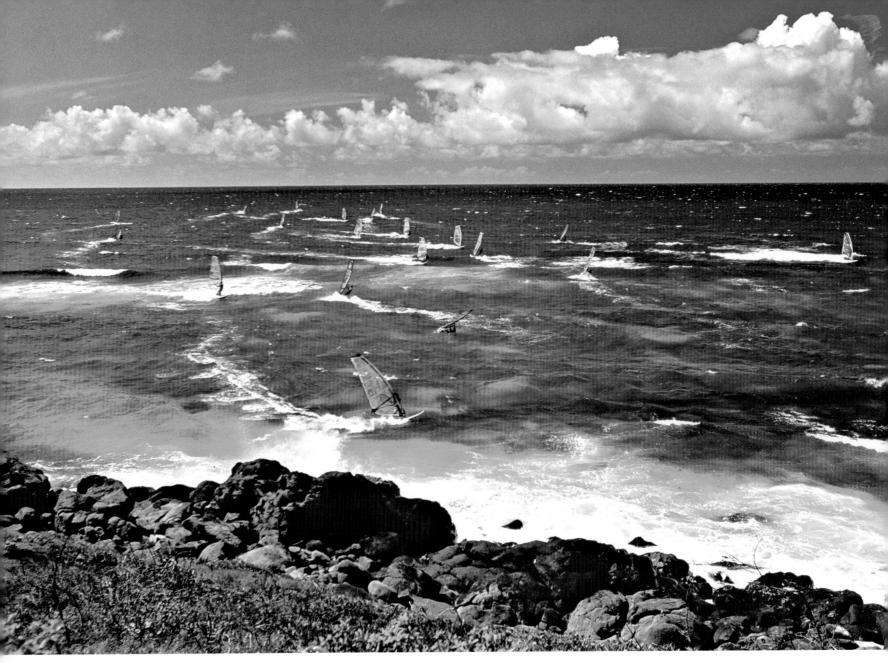

Ho'okipa Beach, Maui's windsurfing Mecca

Previous Page: Gentle off-shore breaks at Baby Beach, Lahaina

Opposite: Lahaina Coconut Palms

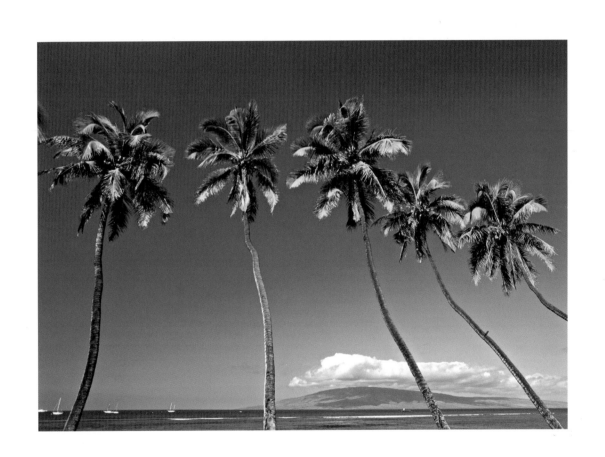

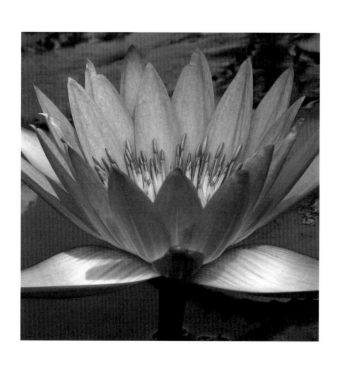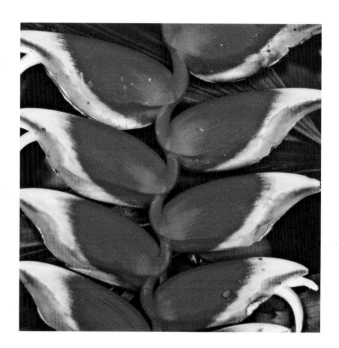

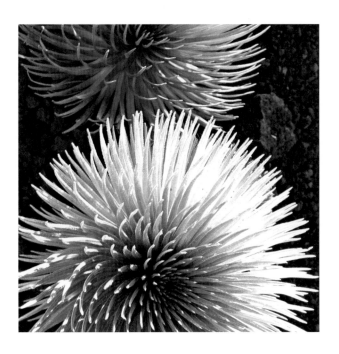
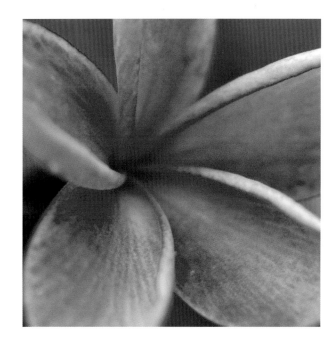

F L O W E R S / P U A (Hawaiian)

(left to right) Water Lily, Hanging Lobster Claws, Silver Sword, Plumeria

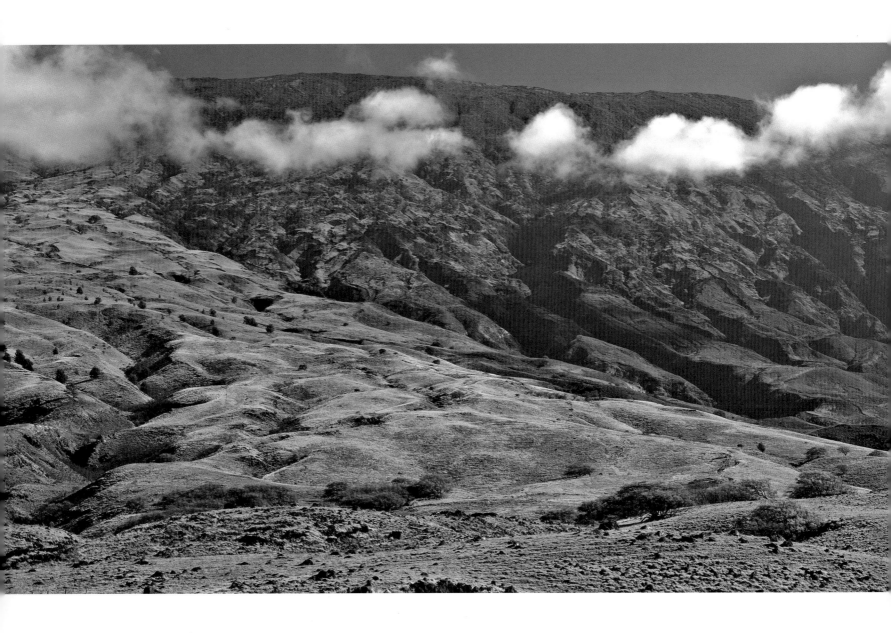

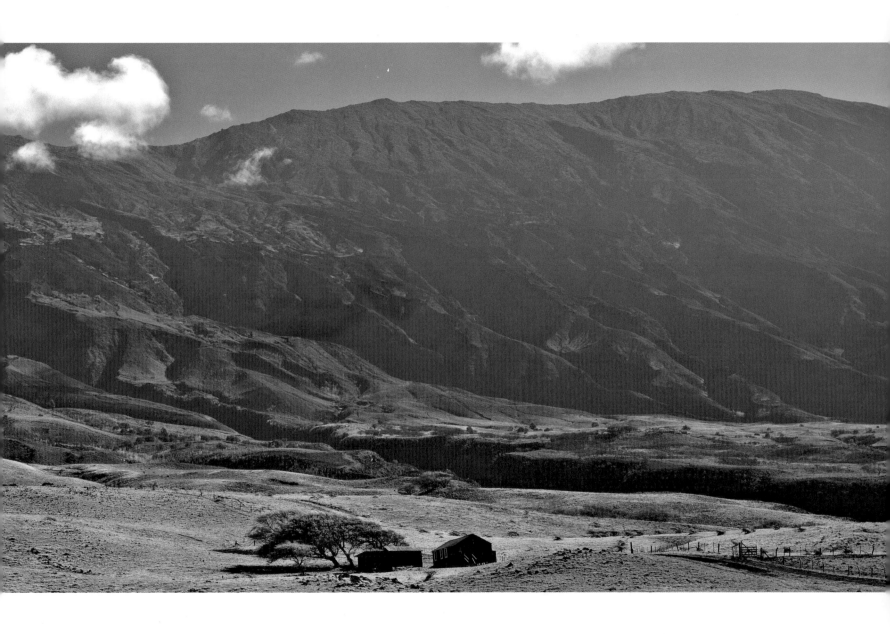

Volcanic moonscapes of South-Eastern Maui, looking towards Haleakala

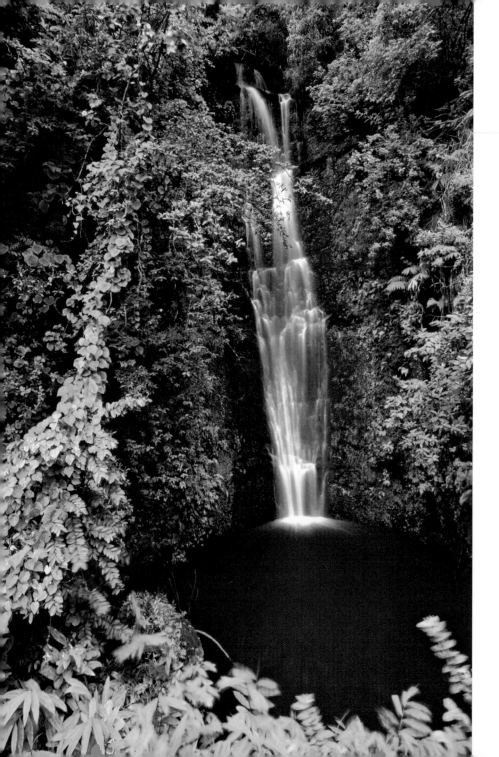

TRANQUILITY

There are hundreds of waterfalls on Maui,
and each is more breathtaking than the
last. Sounds like a cliché, but in this case
it is absolutely true. Each time I thought
I had captured the essence of a waterfall
I would round another corner and be
face to face with yet another of Nature's
magnificent water sculptures.

Hana Waterfall

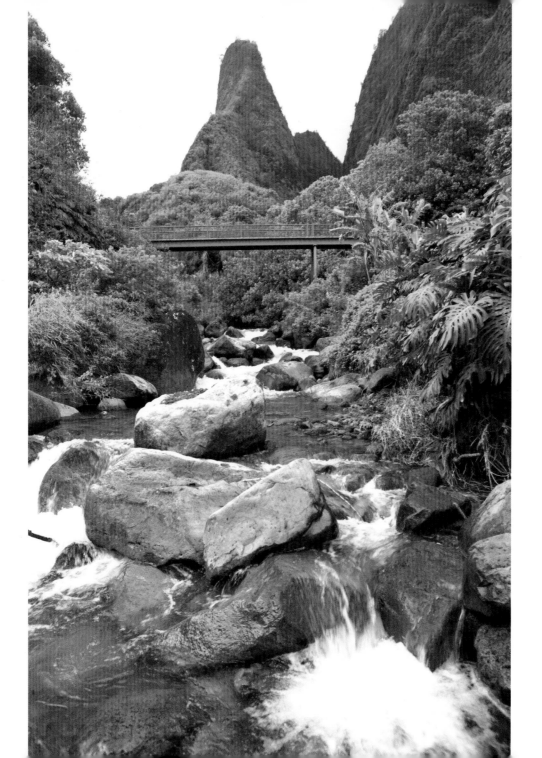

Iao Needle,
West Maui Mountains

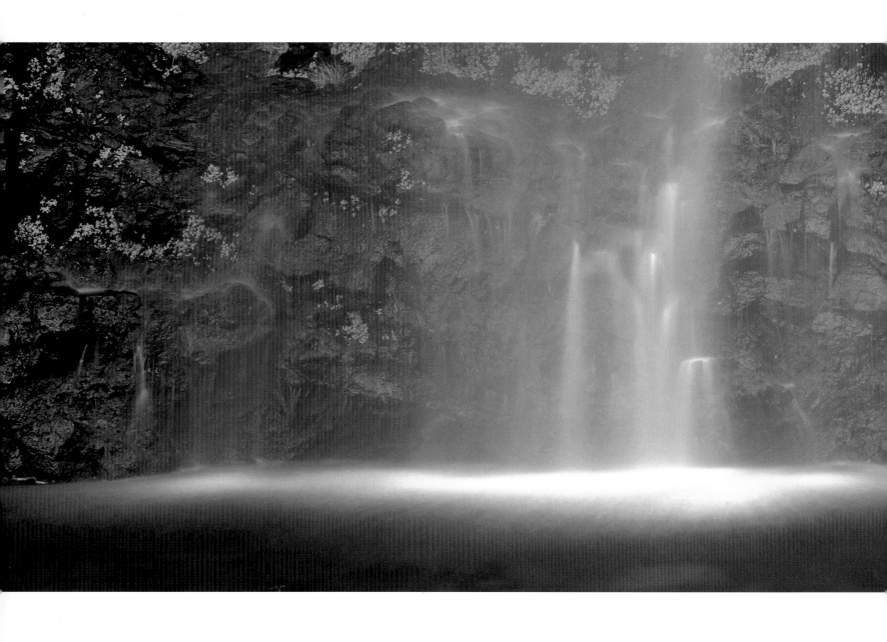

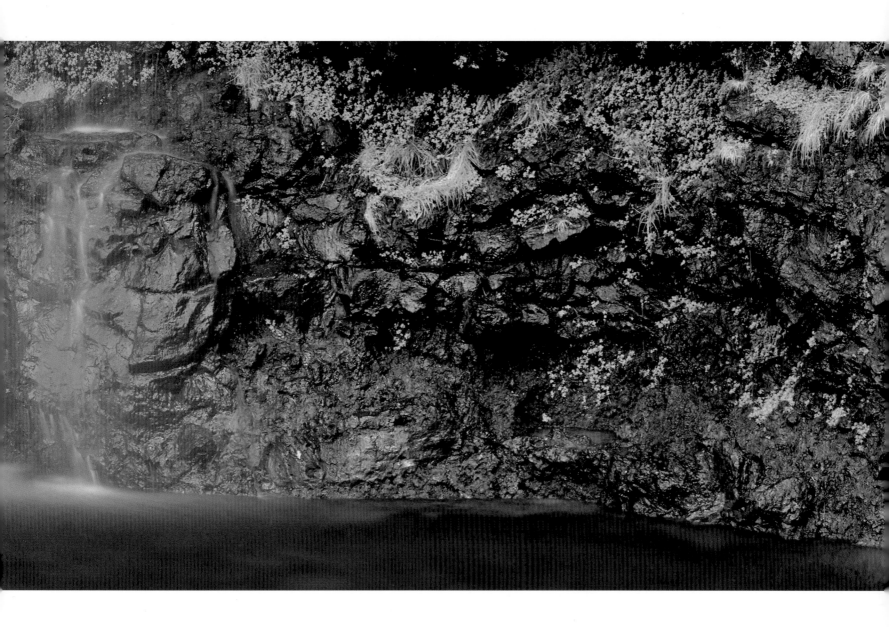

Waimoku Falls, Pipiwai Trail, Hana

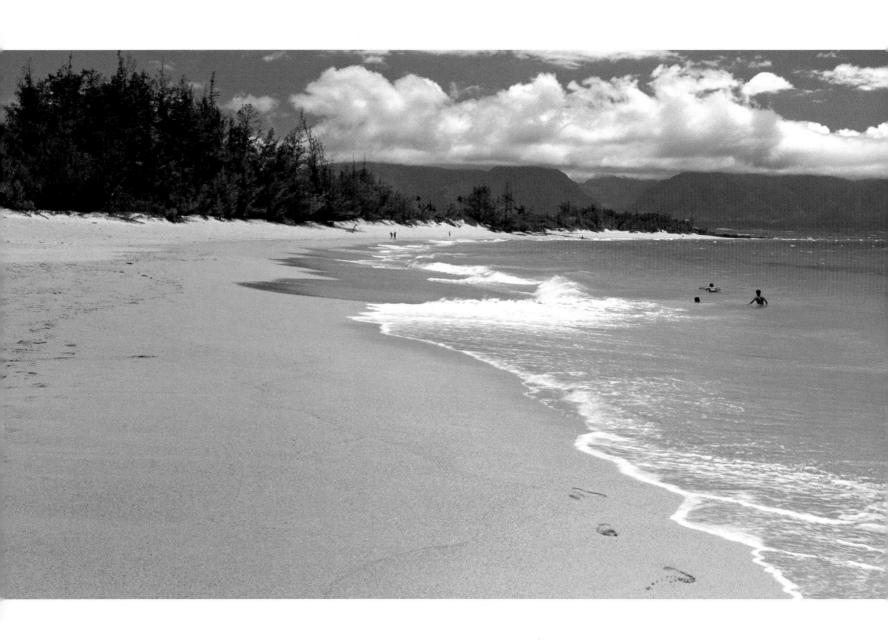

The azure waters of Baldwin Beach, Pa'ia Coast

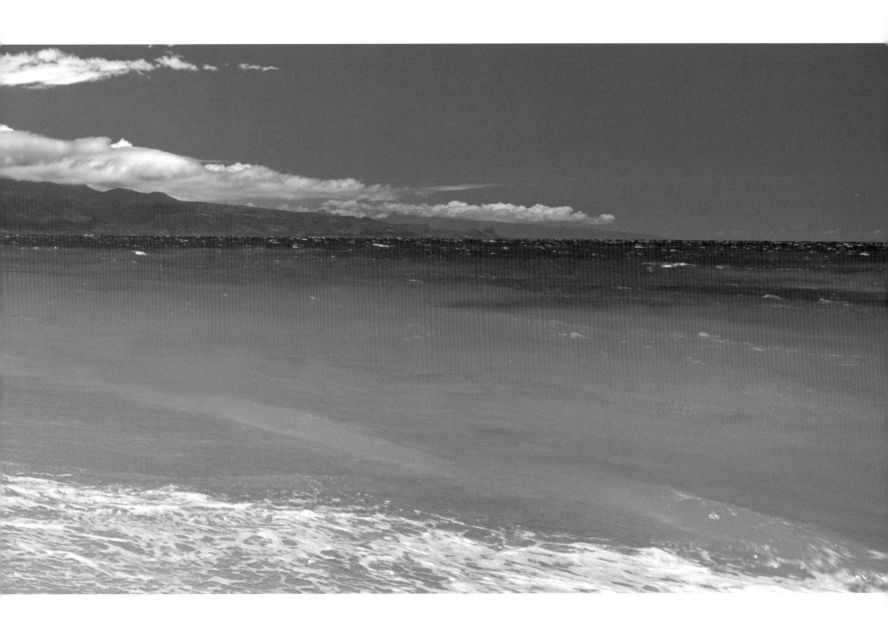

Overleaf: Napili Bay / Humpback Whale

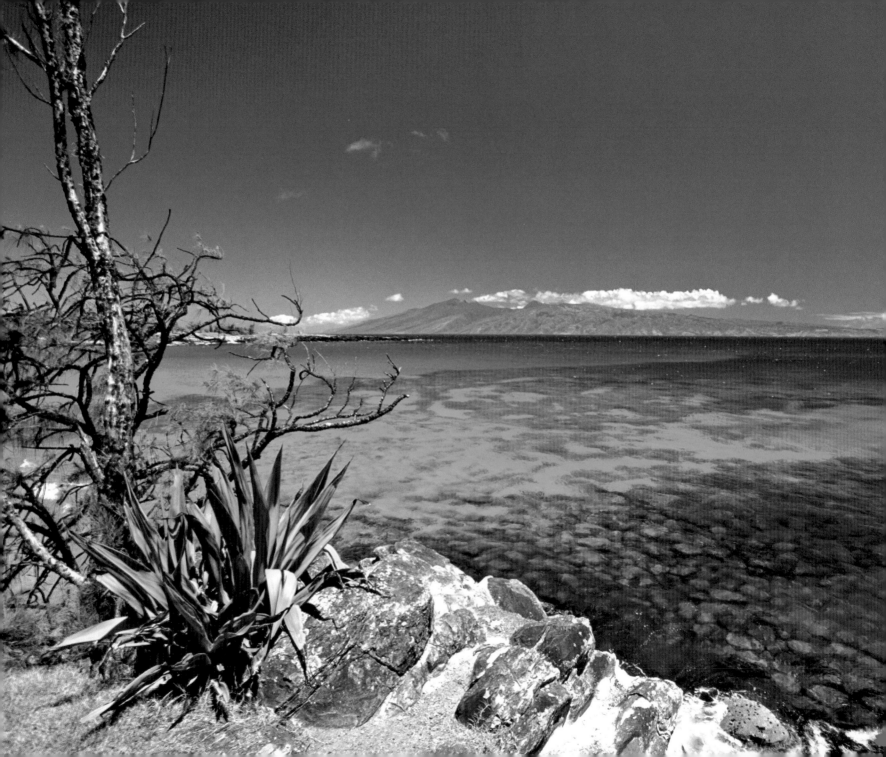

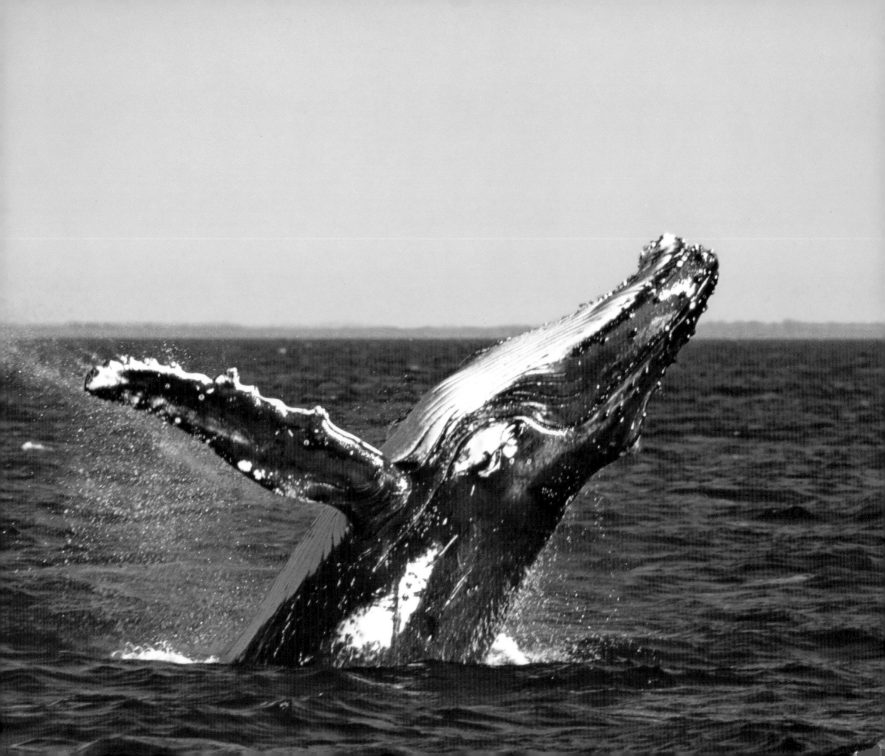

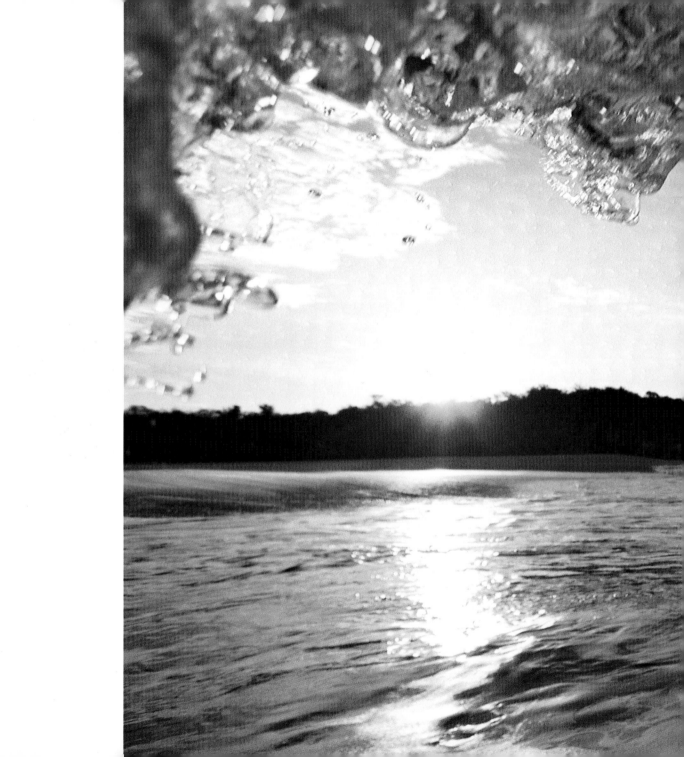

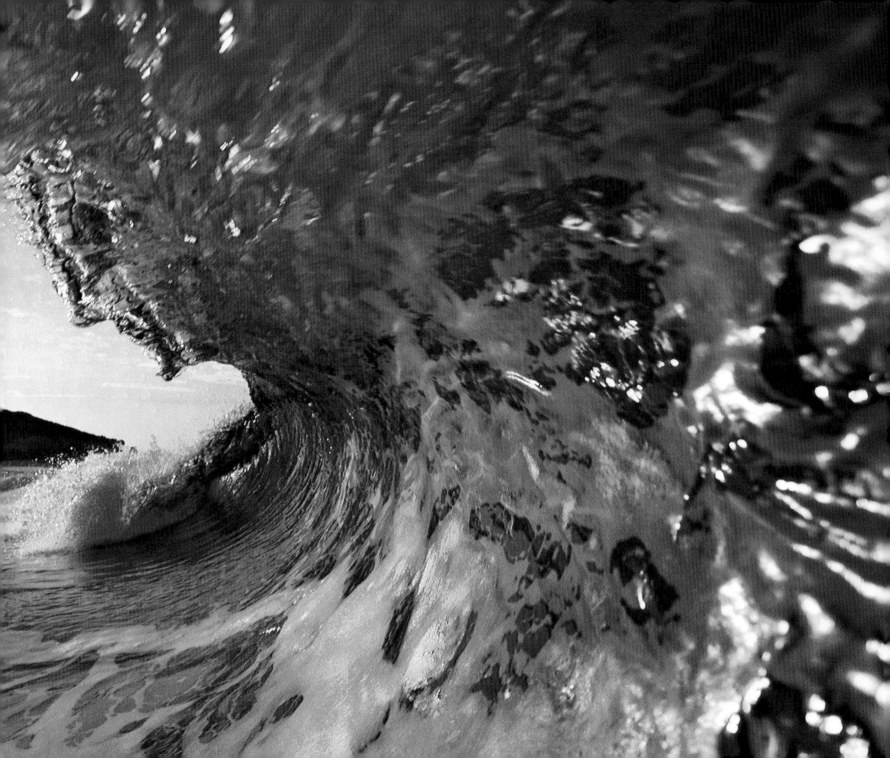

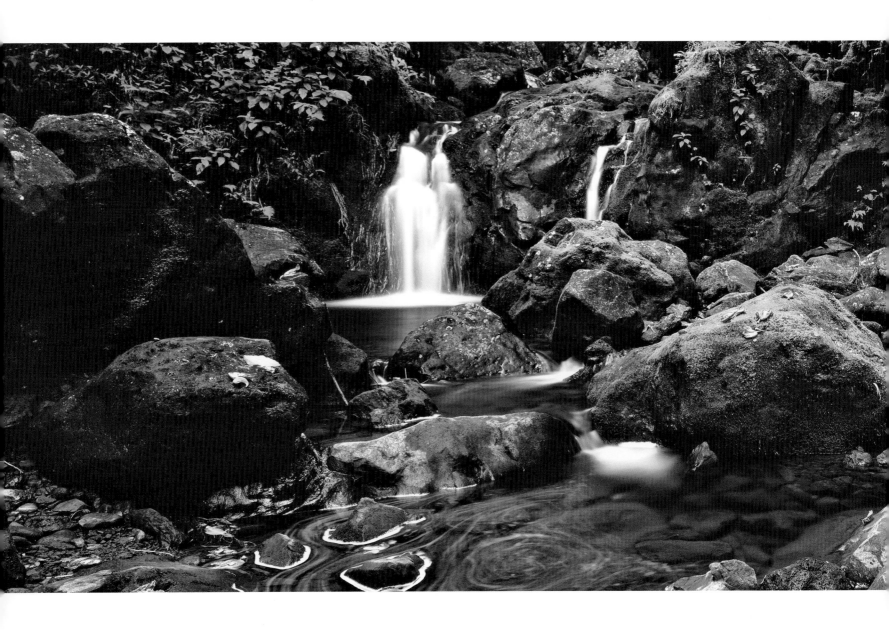

African Tulips provide an eye-catching contrast to the mossy boulders of Pipiwai Stream

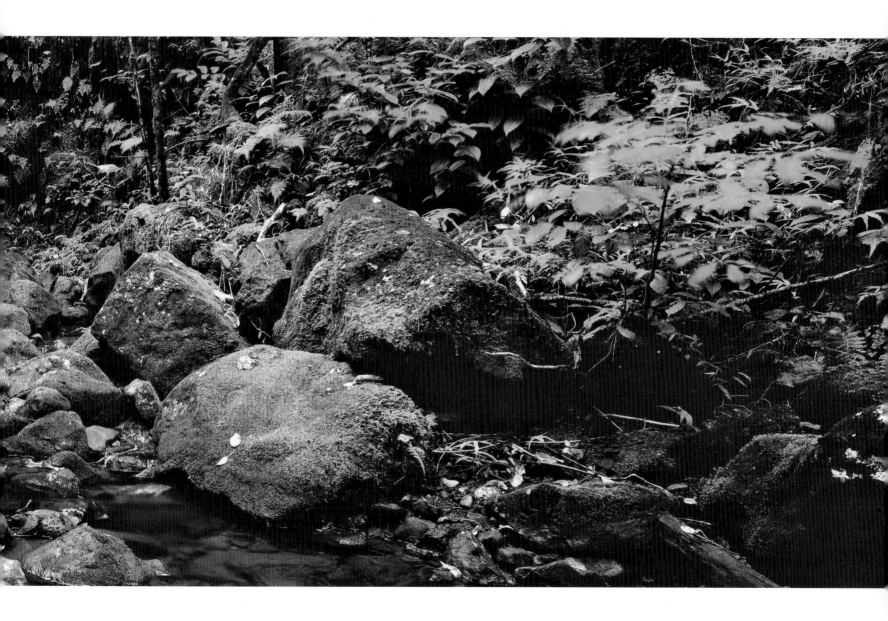

Overleaf: A pastel hued glimpse of Maui from the serene shores of Molokai

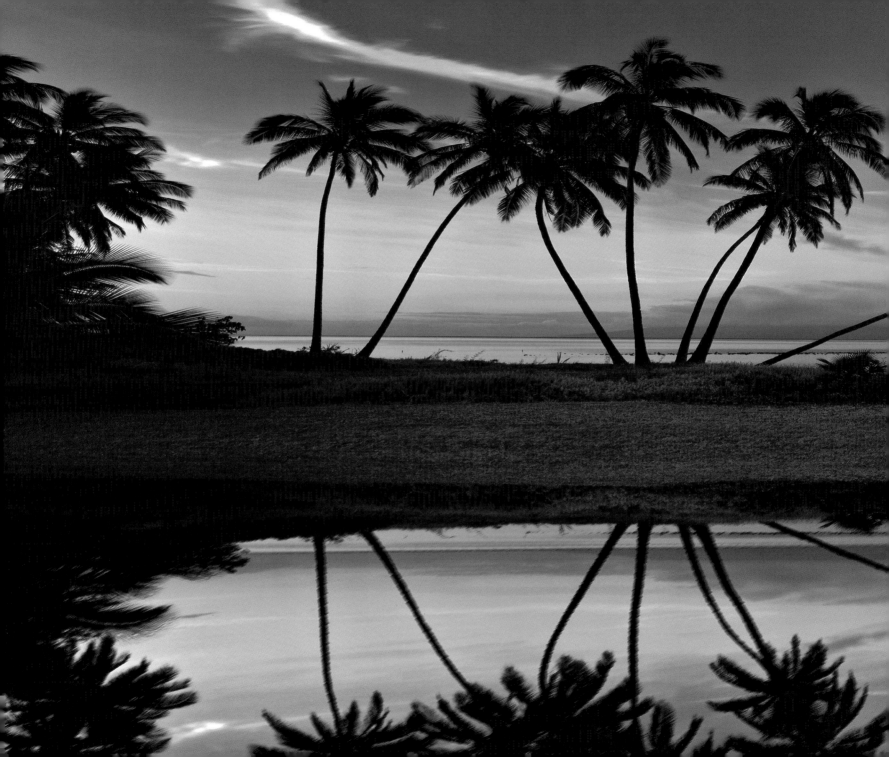

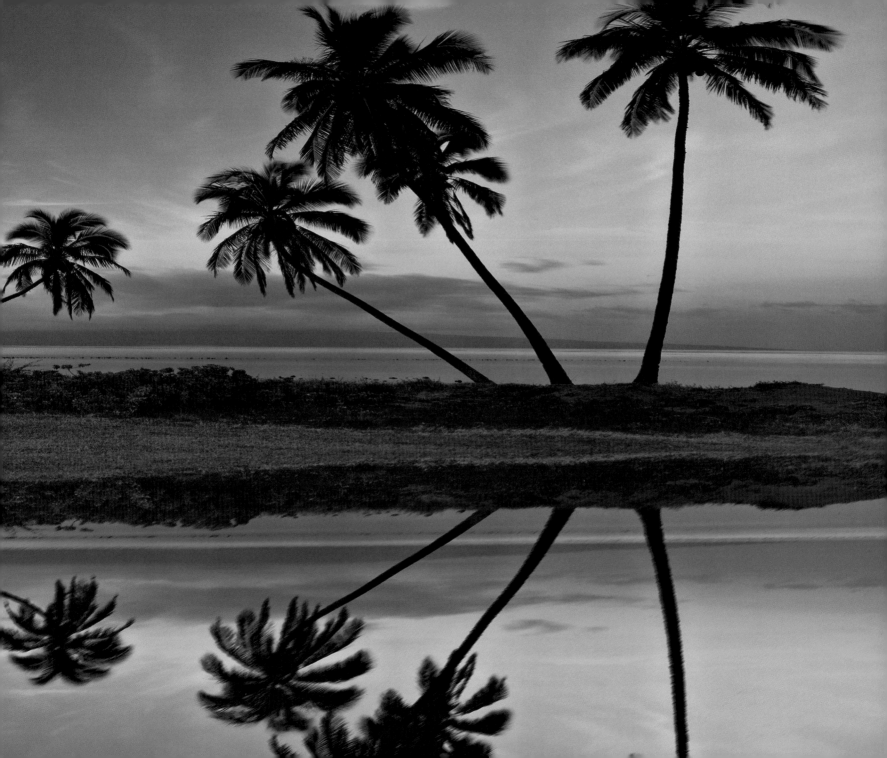

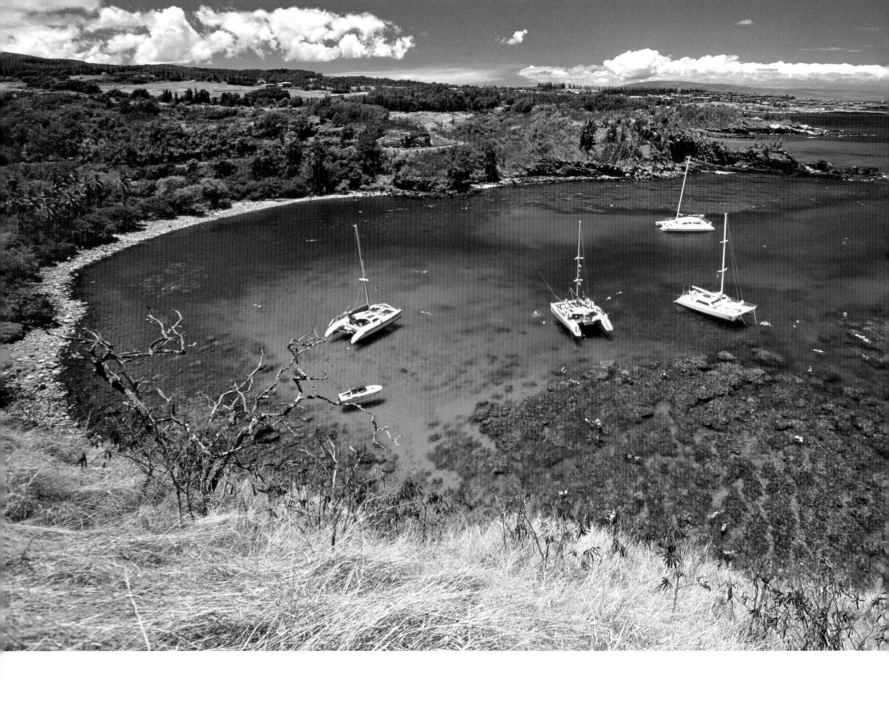

Luxury catamarans pause to snorkel the pristine waters of Honolua Bay

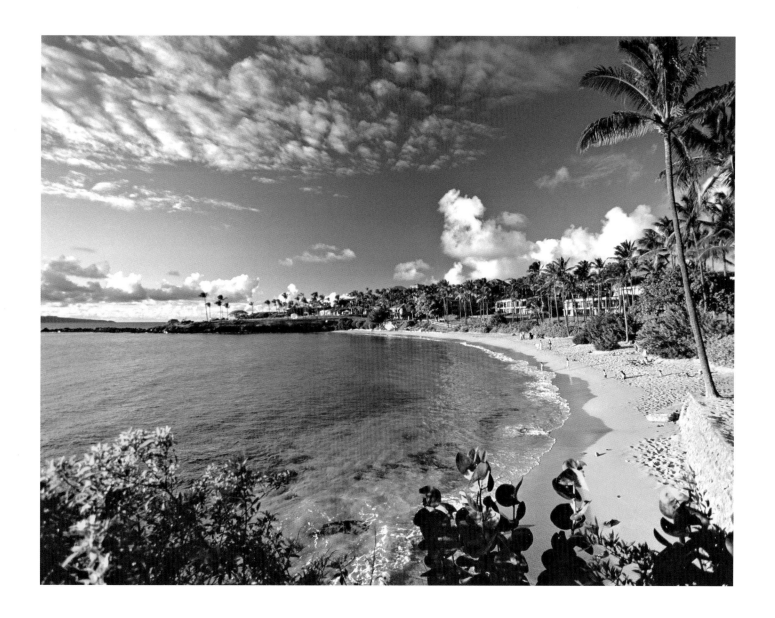

Kapalua Beach

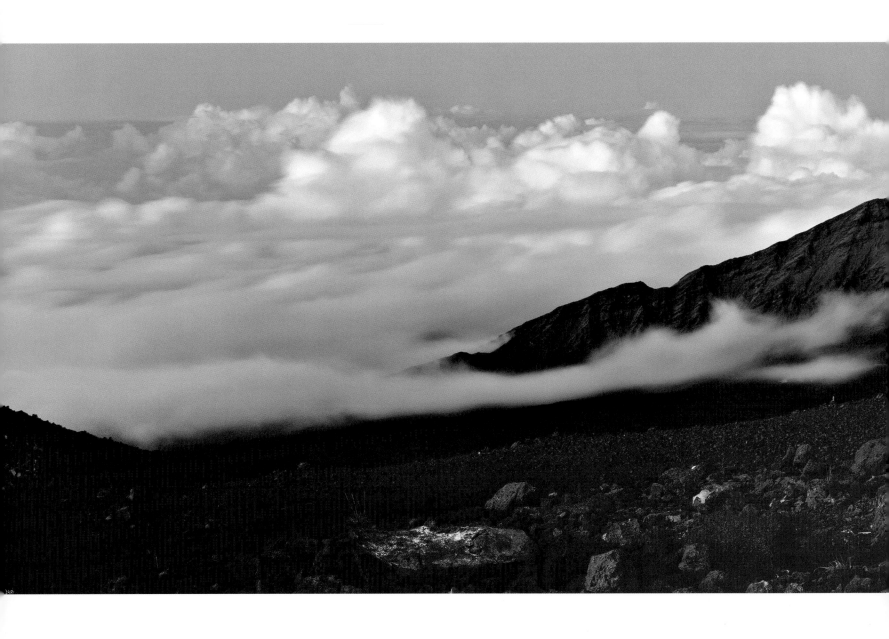

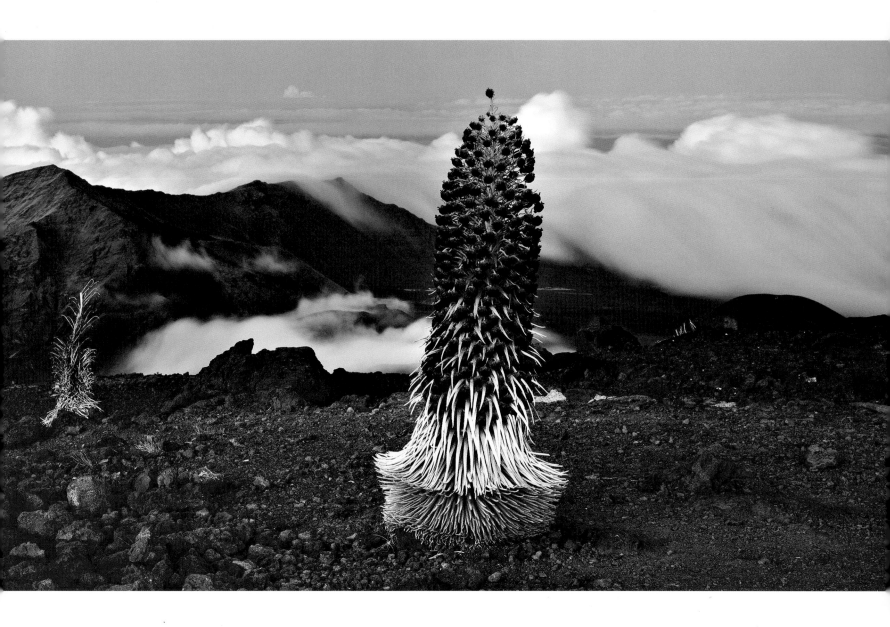

Silversword, Haleakala Crater

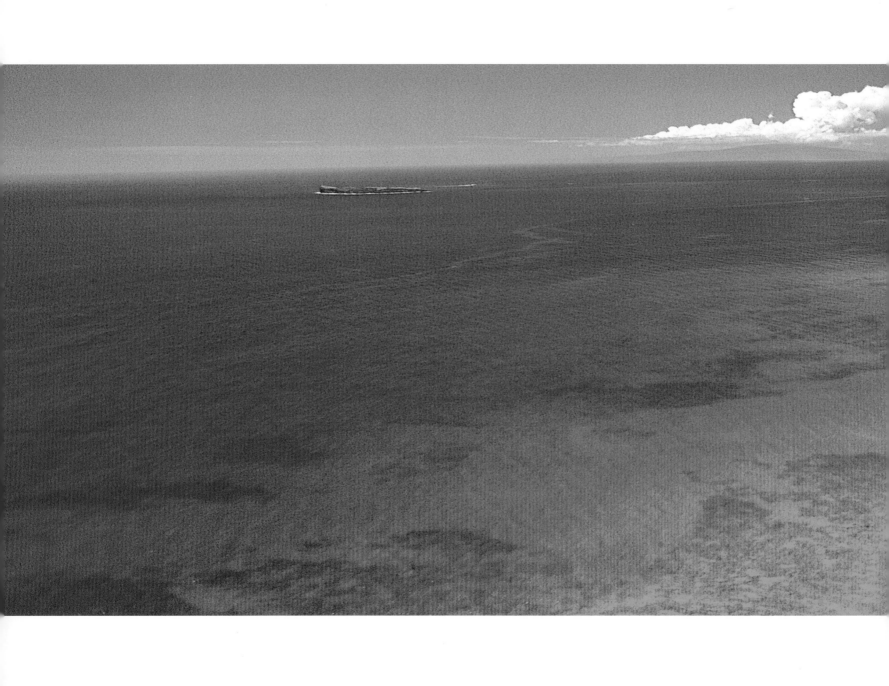

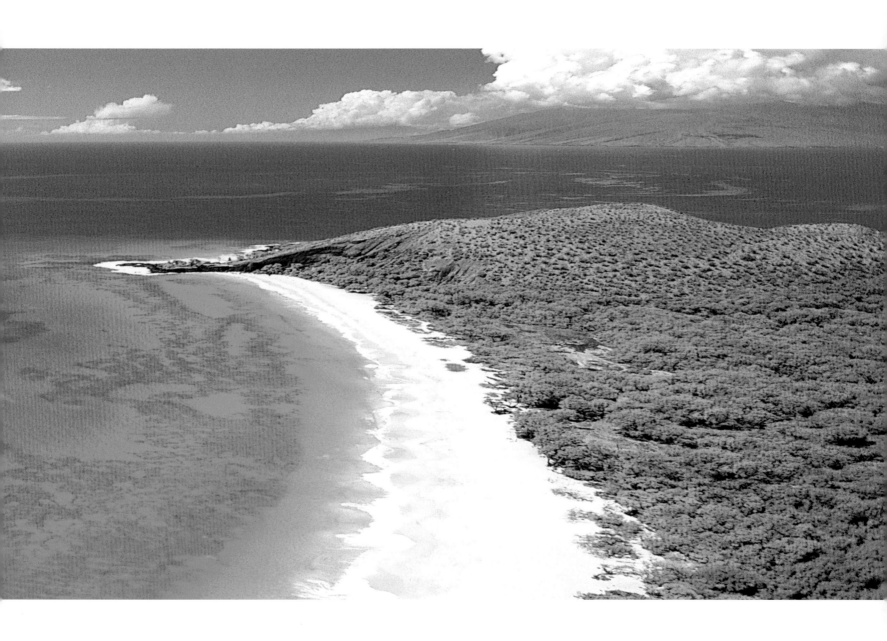

Makena Beach, Maui's turtle haven

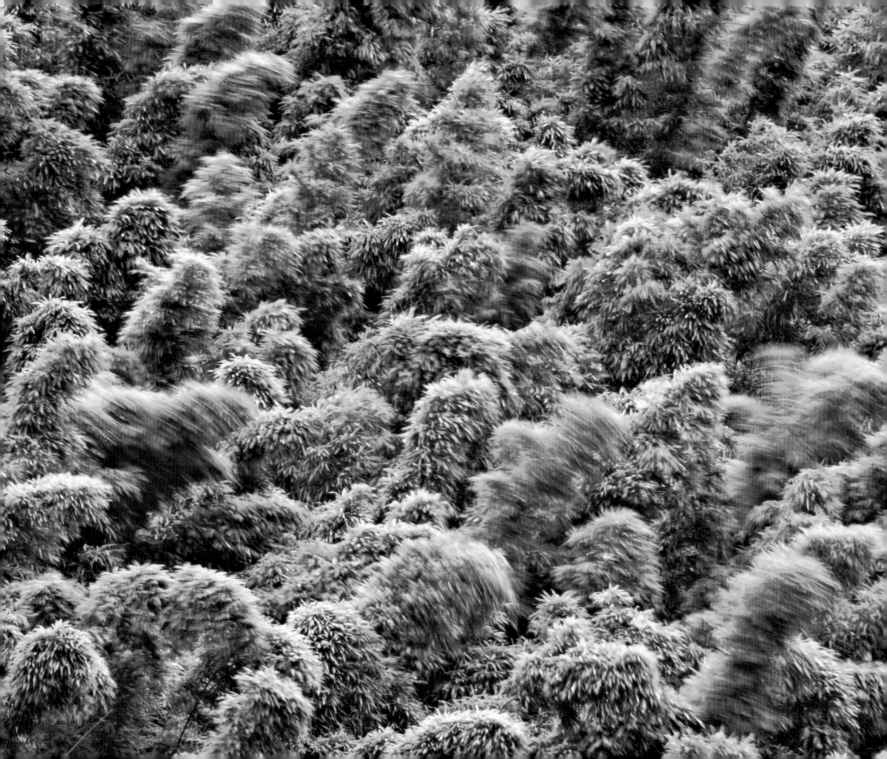

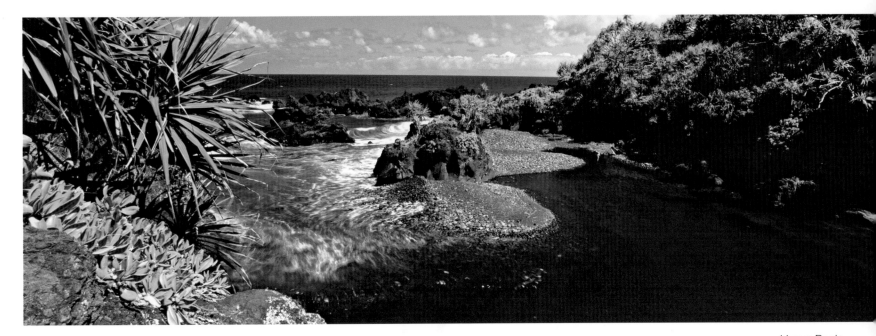

Venus Pools

CARVED BY A VOLCANO

Millennia of volcanic eruptions and pounding seas have shaped Maui's dramatic
coastline. From the sheer cliffs of the Kalaupapa Peninsula to the shimmering
white sands of Makena Beach every mile presents a unique vista of mythical
islets, craggy rock pools and crater like reefs.

Opposite: A vibrant Bamboo forest from the Hana Highway

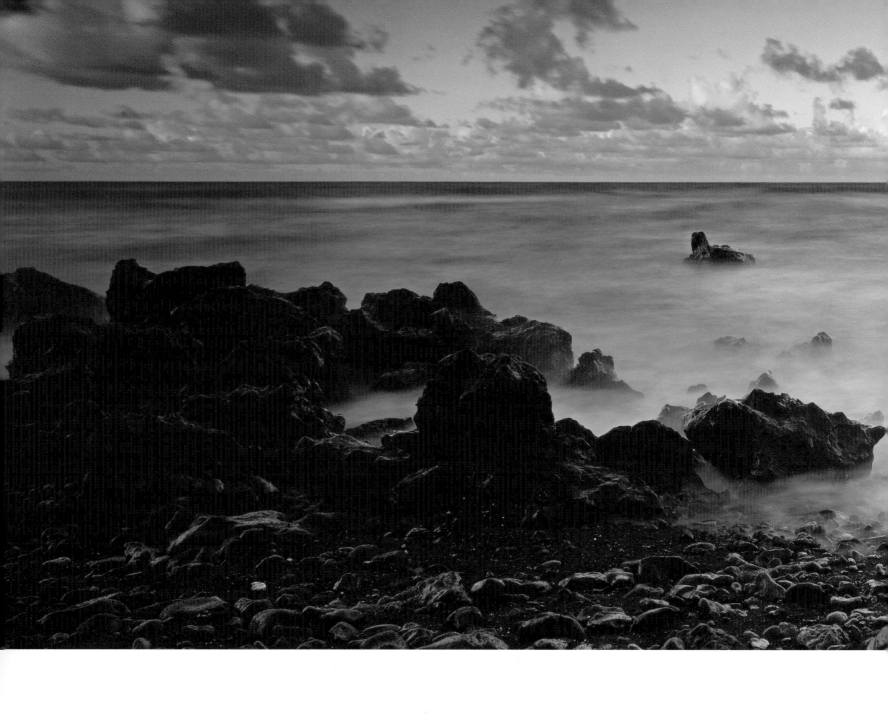

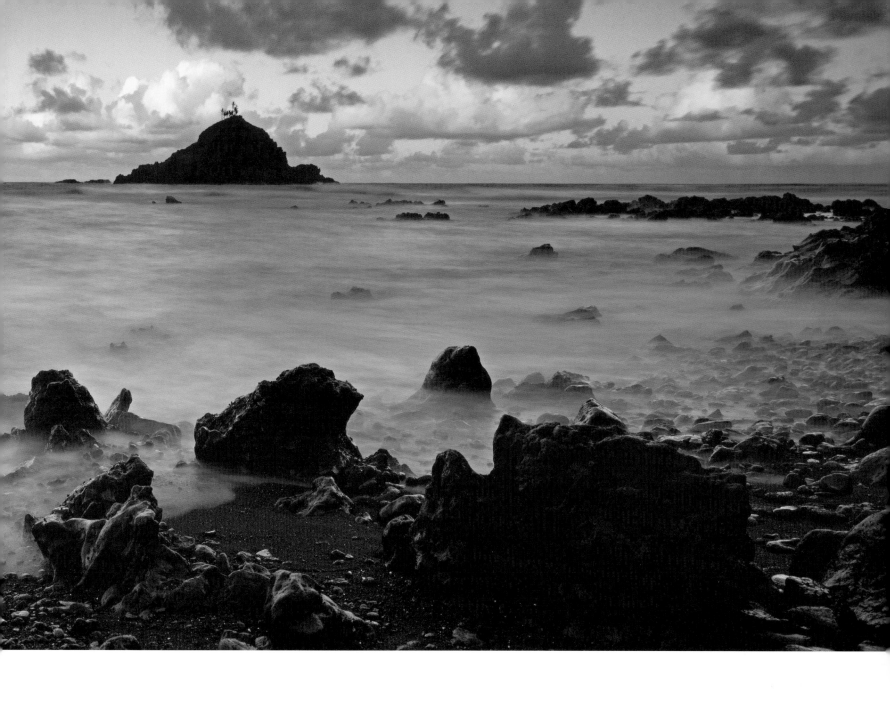

Sunset over the deserted Alau Island, Koki Beach

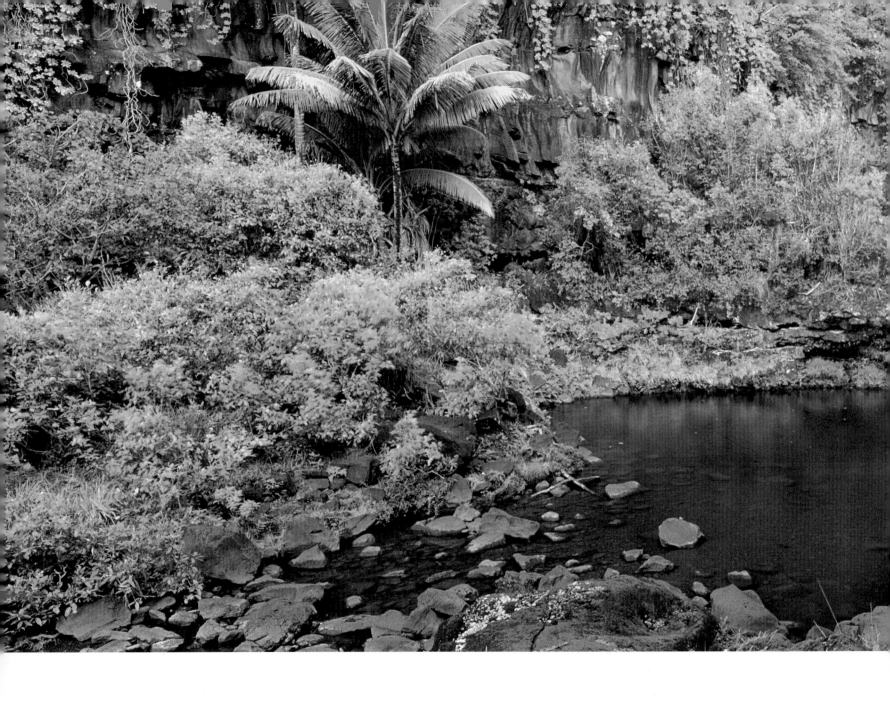

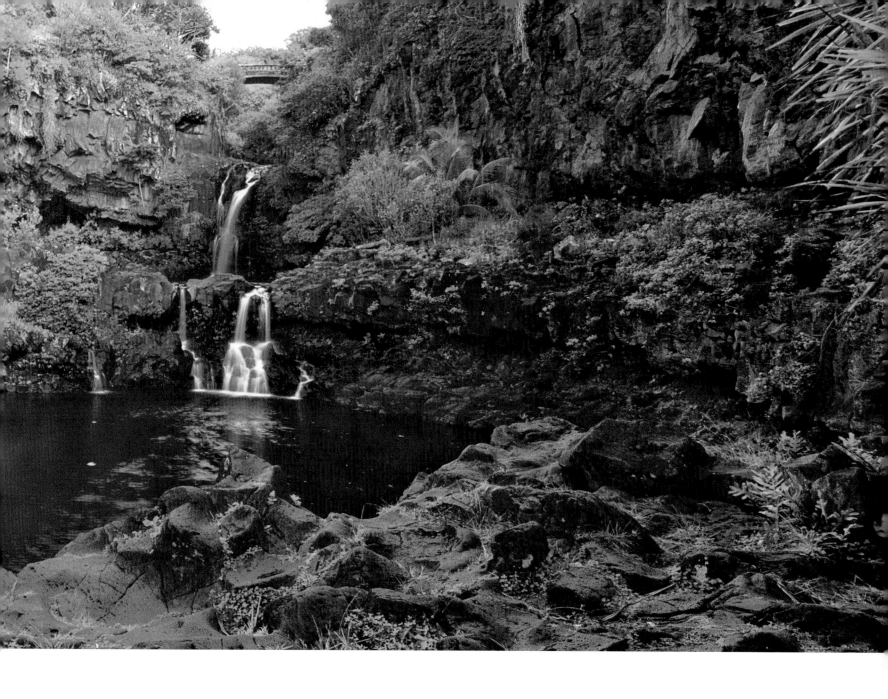

Oheo Gulch, Seven Sacred Pools, Hana.

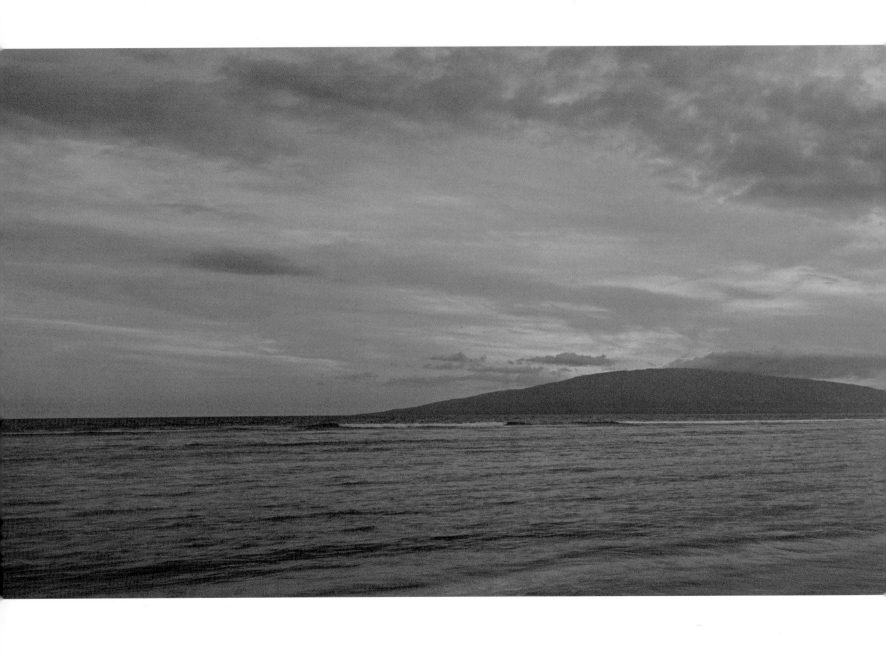

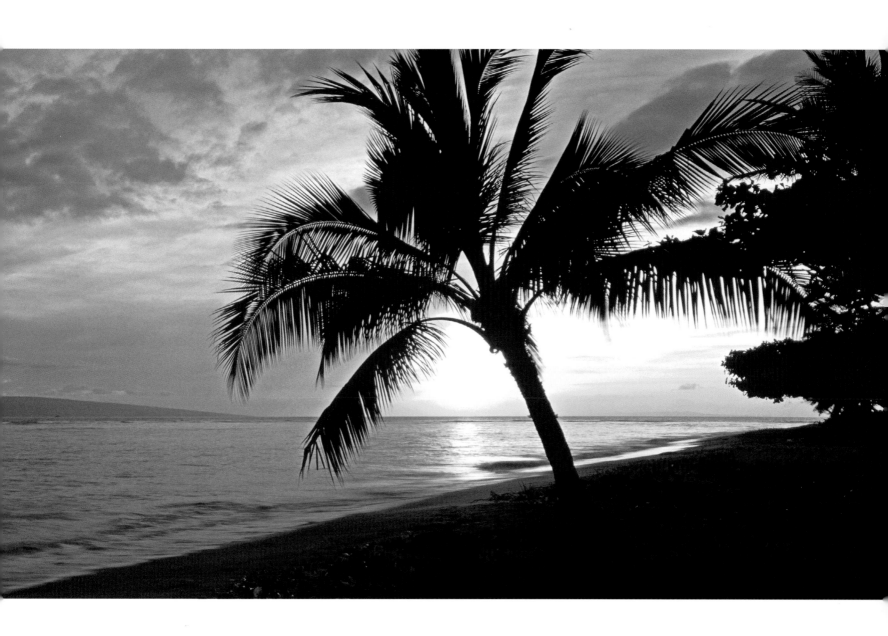

Sunset silhouette, Baby Beach, Lahaina

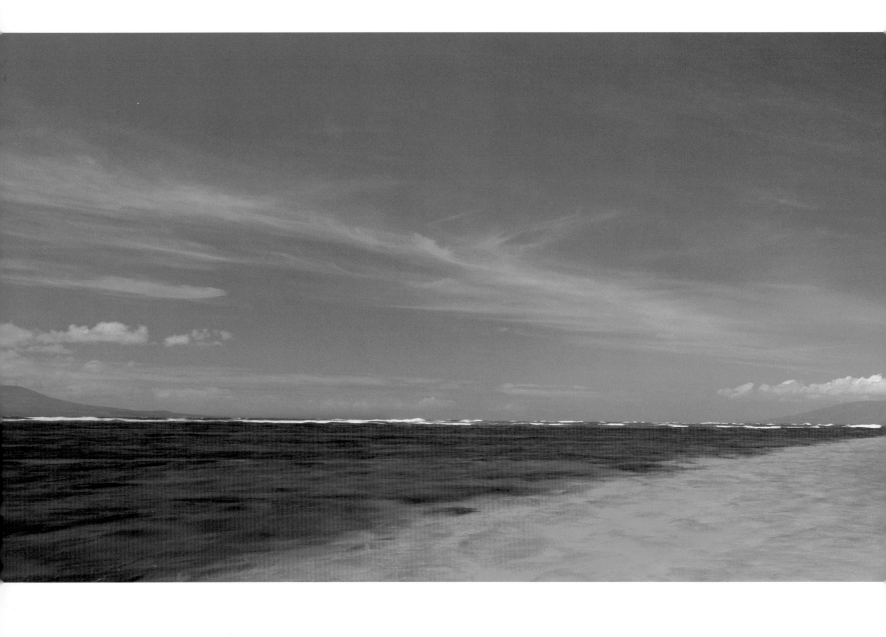

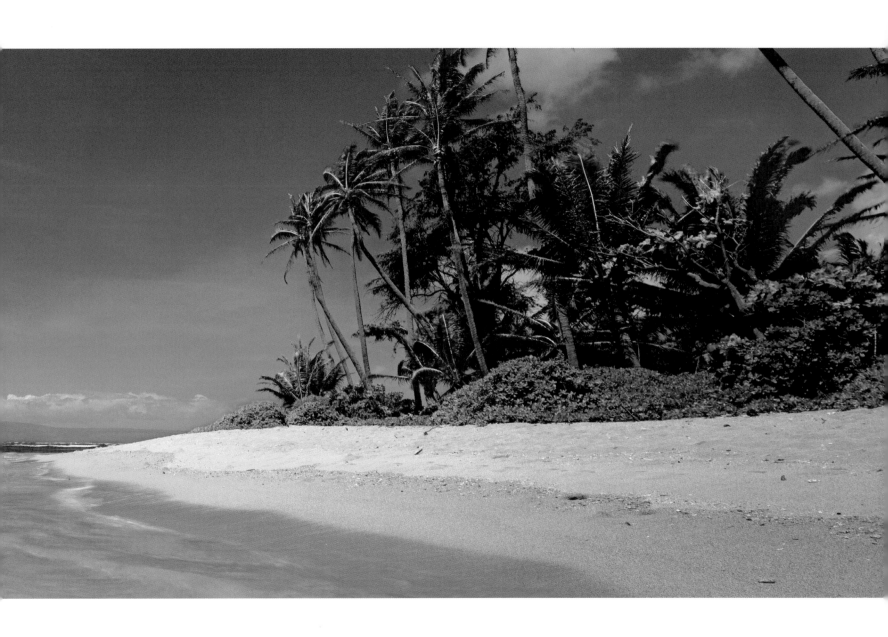

A slice of paradise at Murphy Beach, Molokai

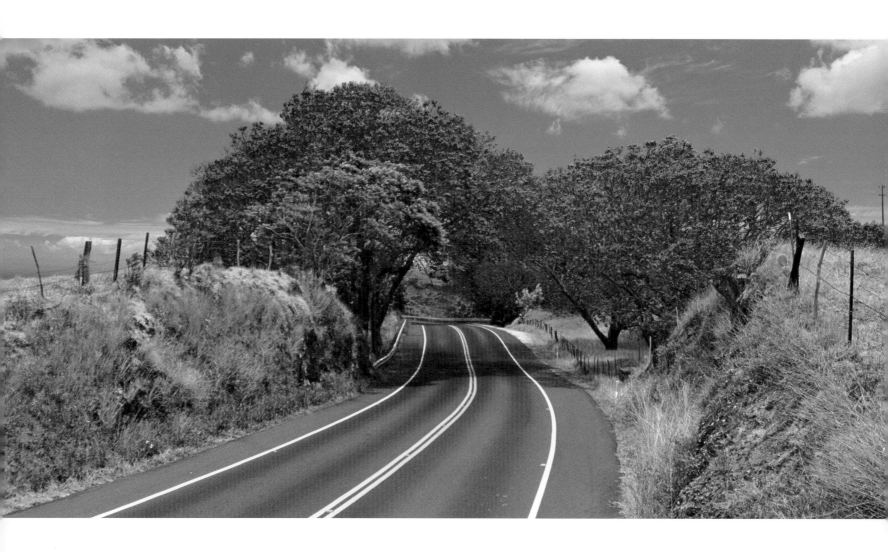

Spring blooming Jacarandas fringe the Haleakala Highway

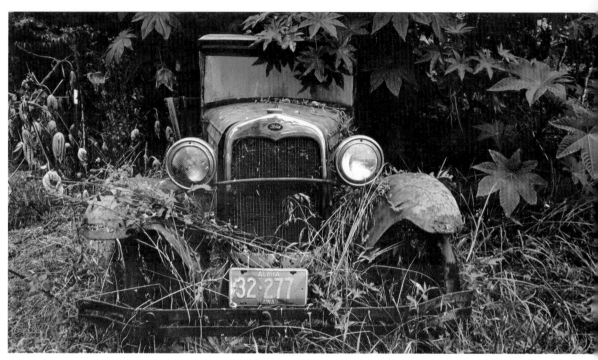

Kula

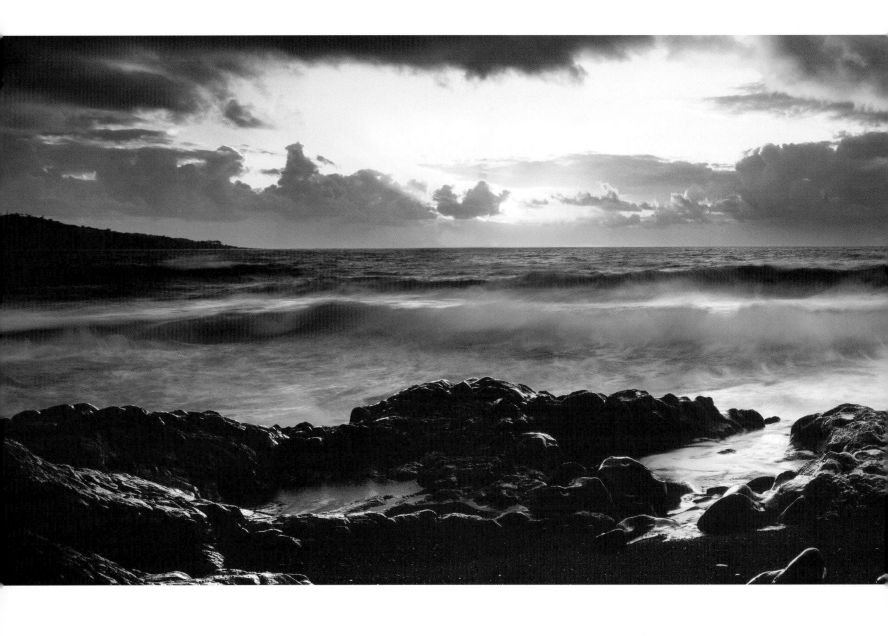

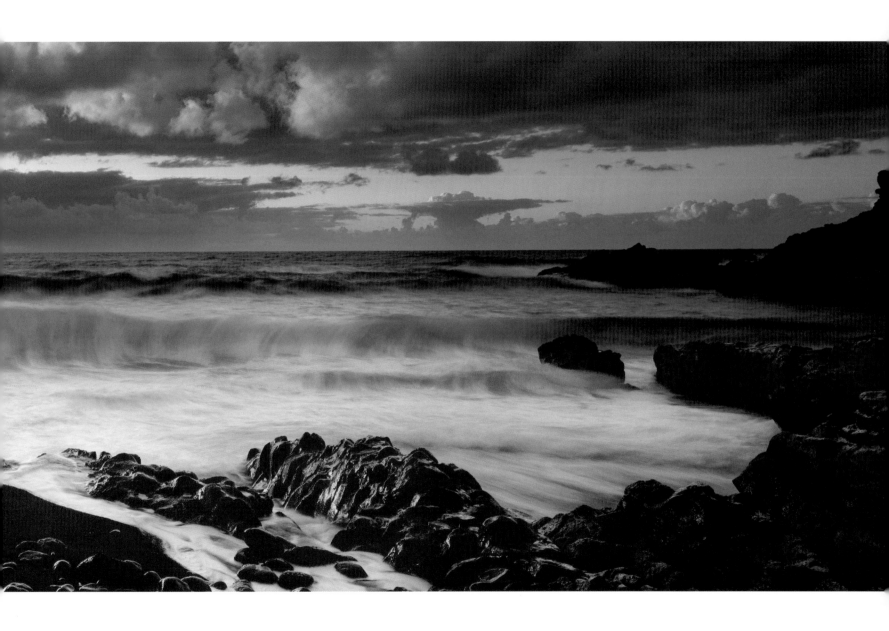

The calm before a storm, a mystical sunrise at the Seven Sacred Pools, Hana

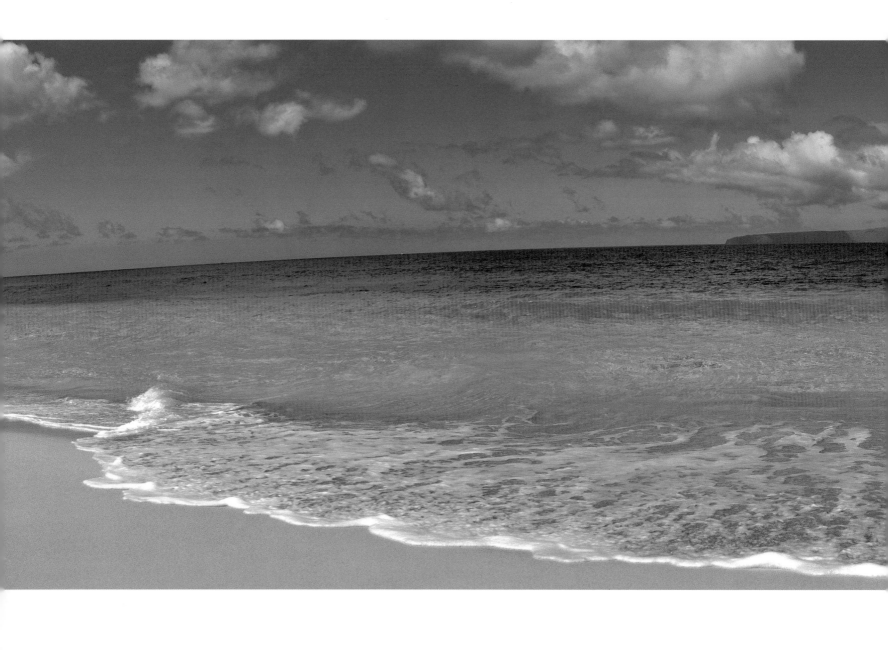

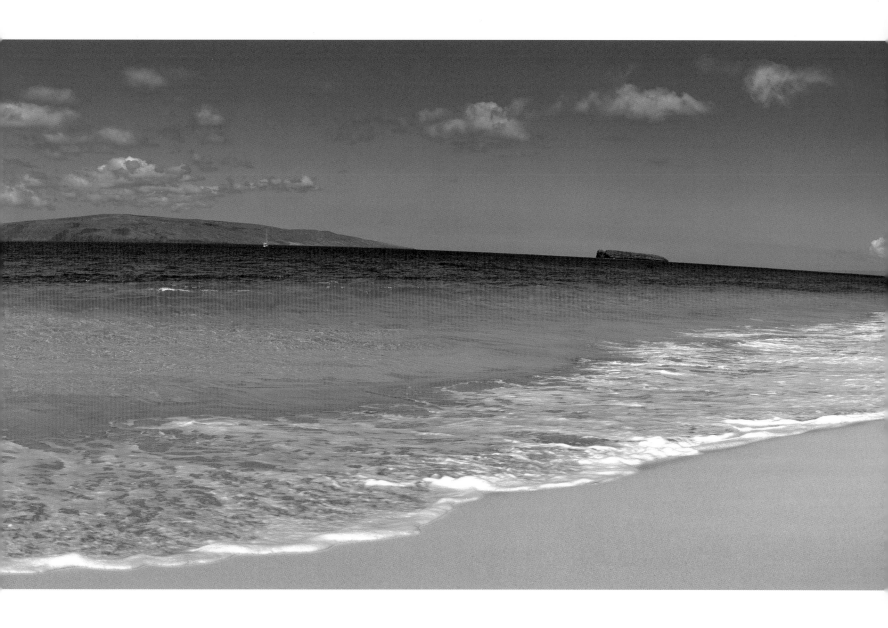

Pristine waves lace the sizzling golden sands of Big Beach, Makena.

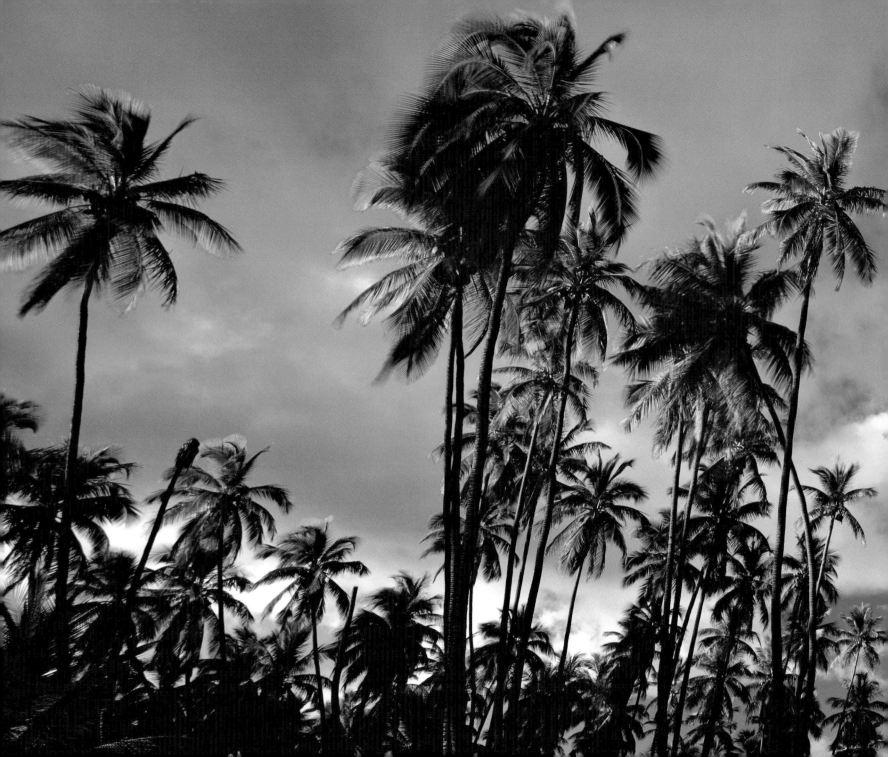

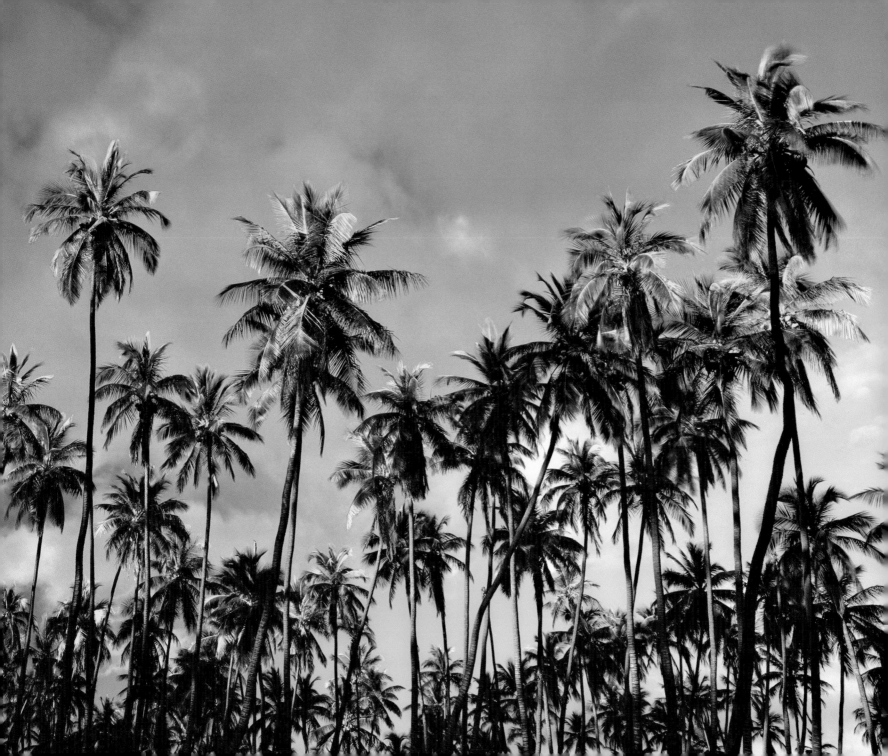

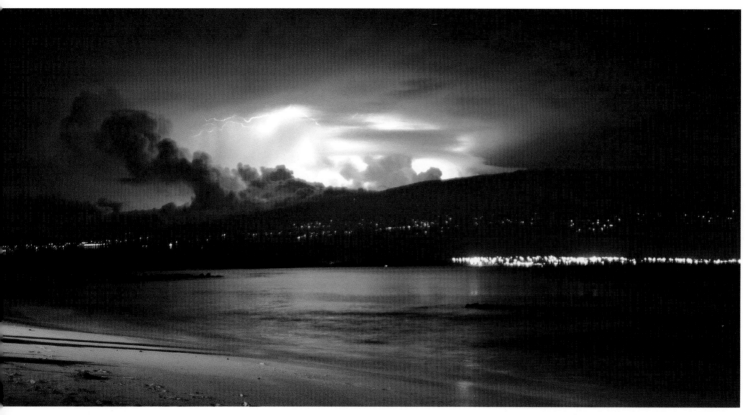

Electrical storm lights up Haleakala

Opposite: Another magical Lahaina sunset

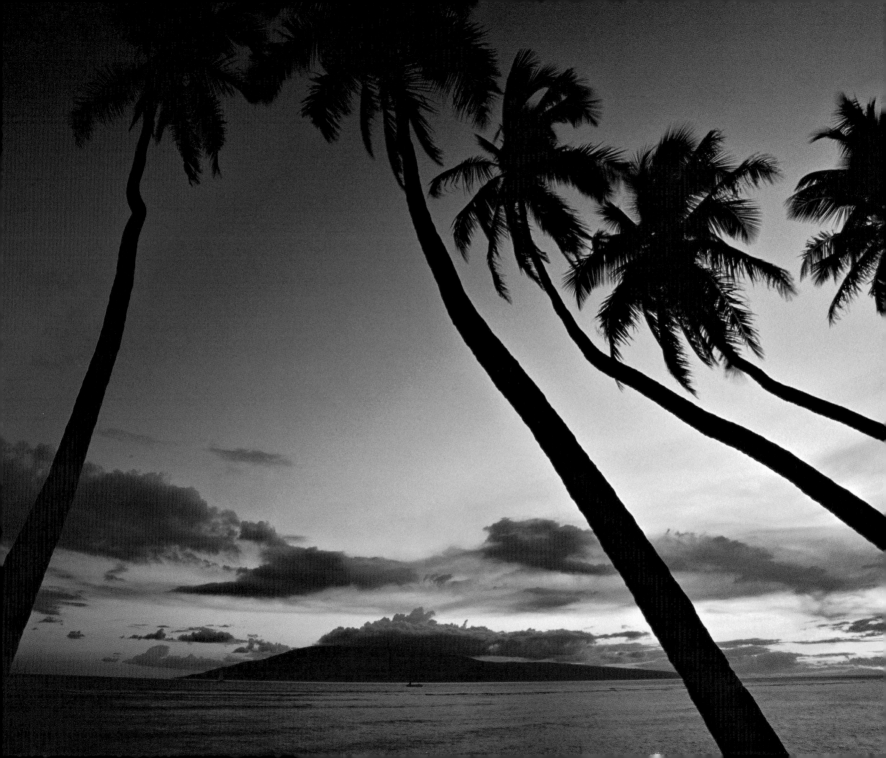

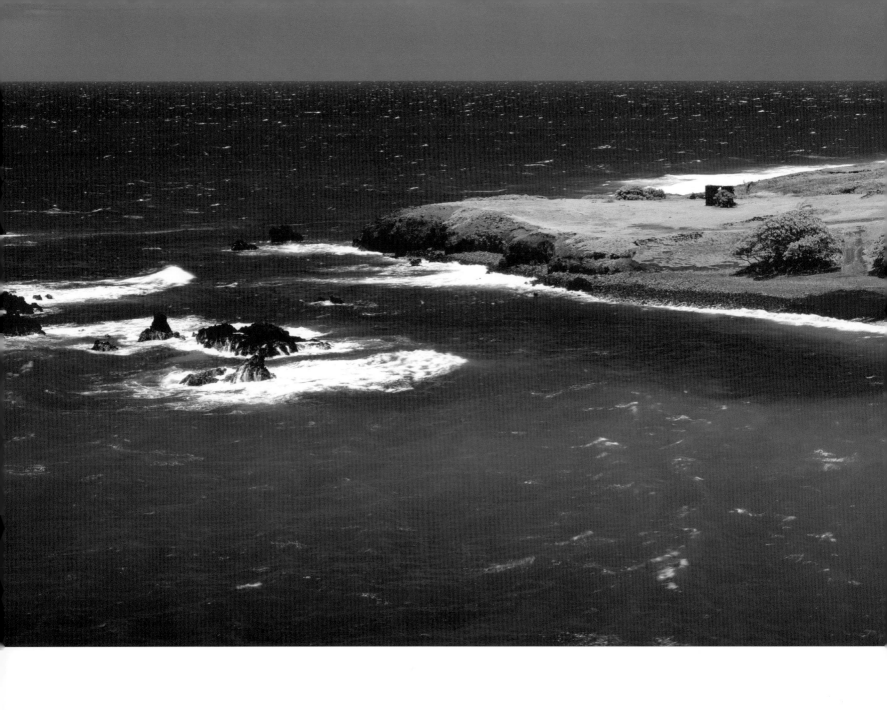

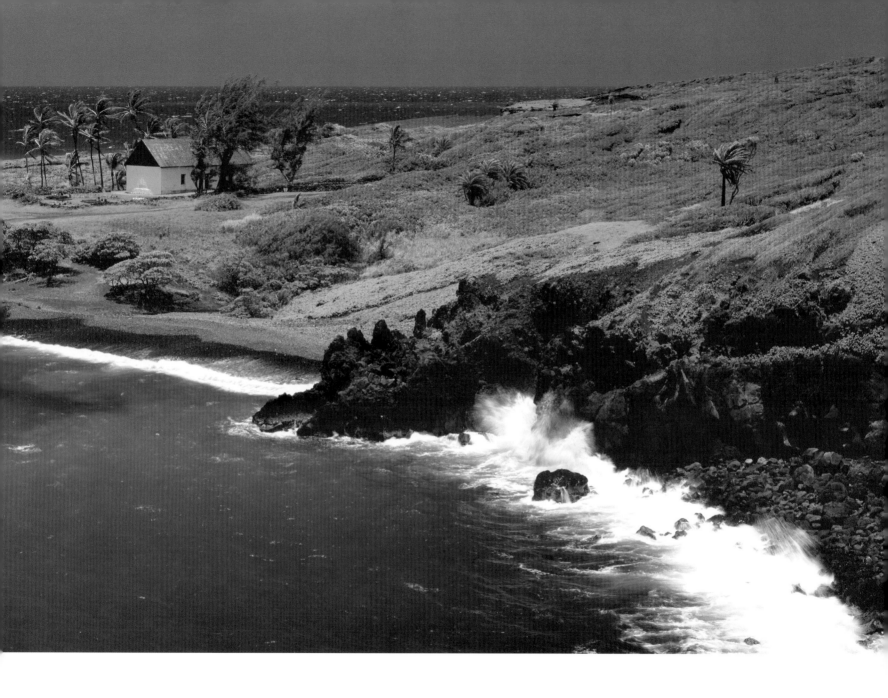

Huialoha Church, Kaupo

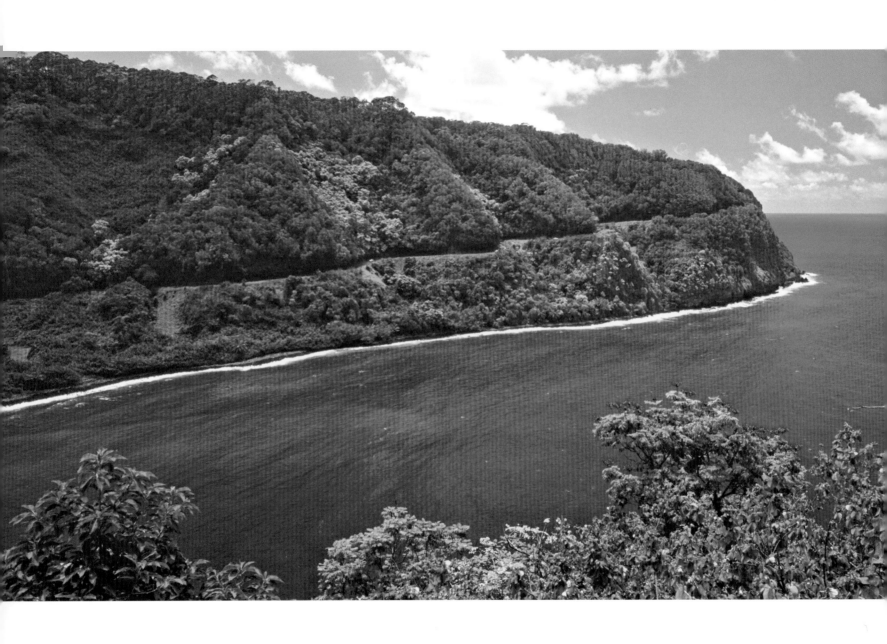

Carved into the mountainous cliff faces of East Maui, the Hana Highway is both treacherous and spectacular

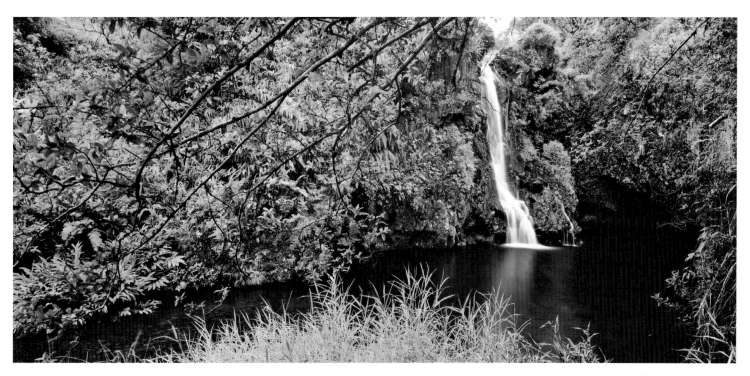

Hanawi Falls, Hana

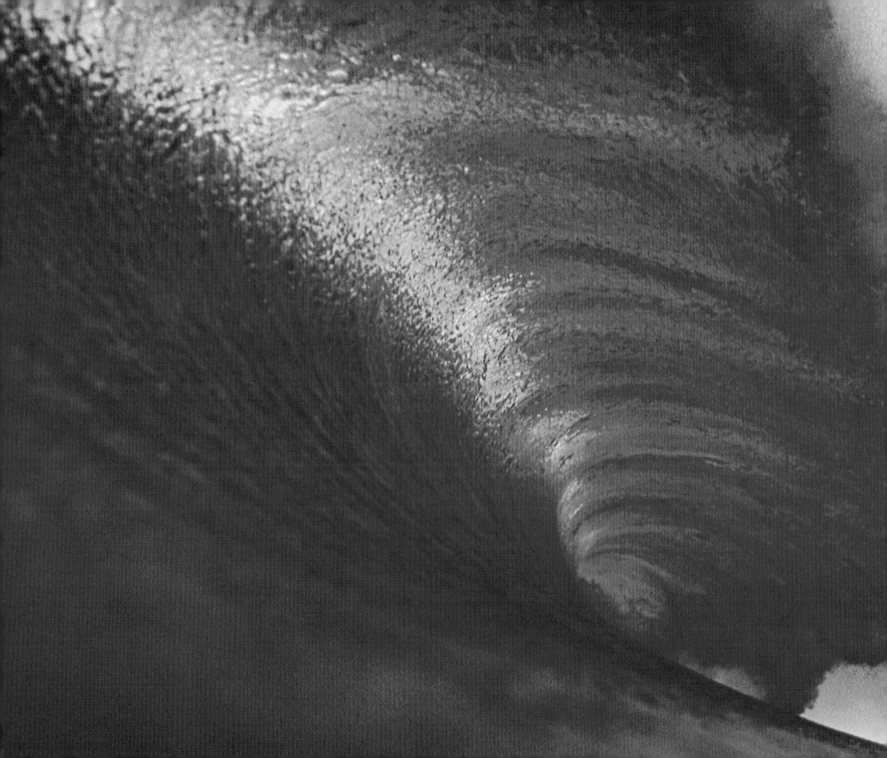

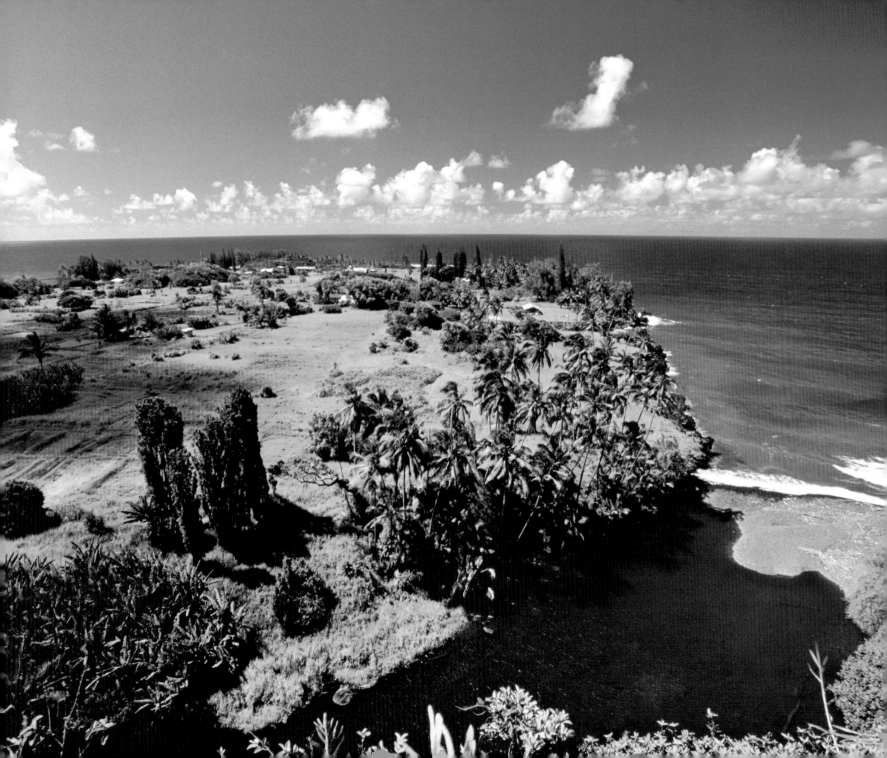

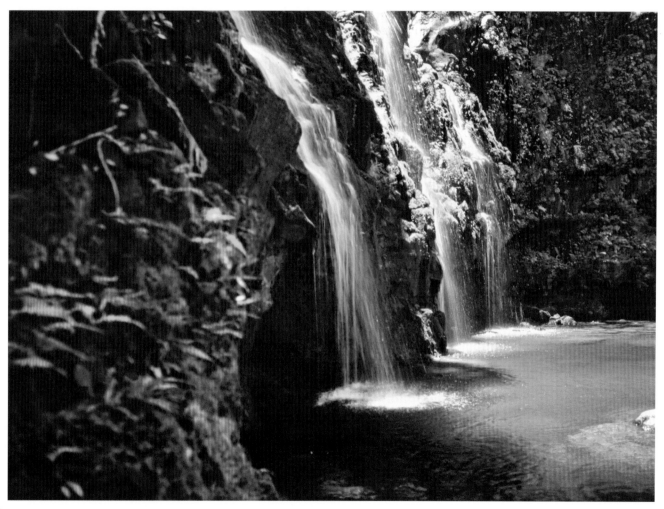

Opposite: A birds-eye view of the quaint Wailua farming village

Waikani Falls, Hana

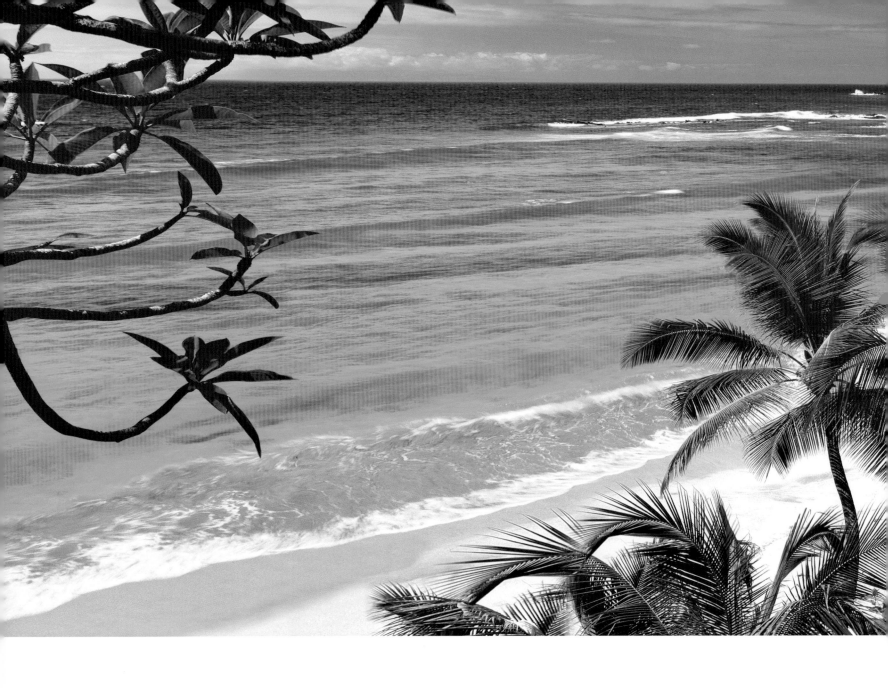

Rainforest meets the sea at Hamoa Beach, Hana

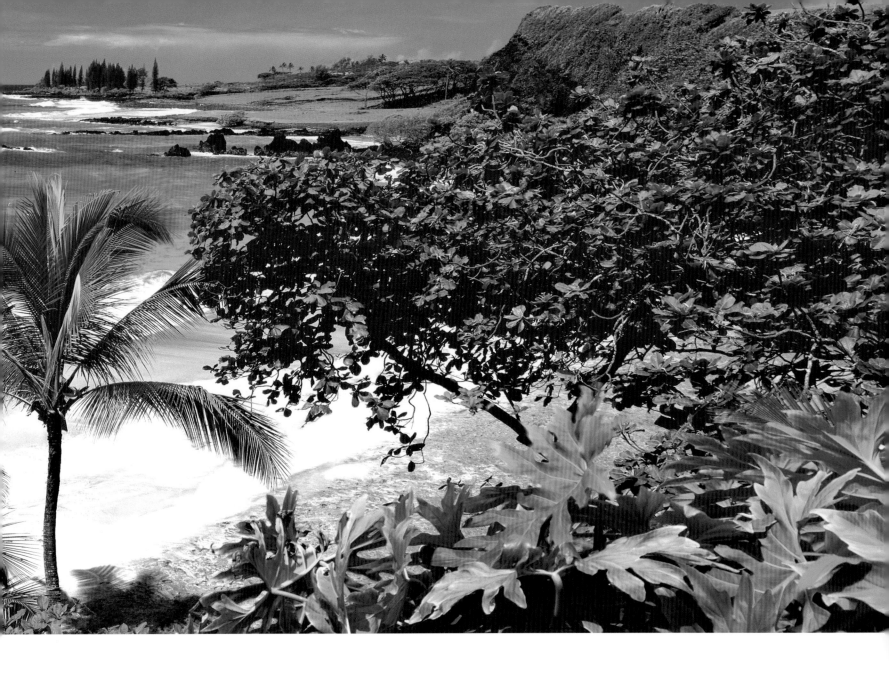

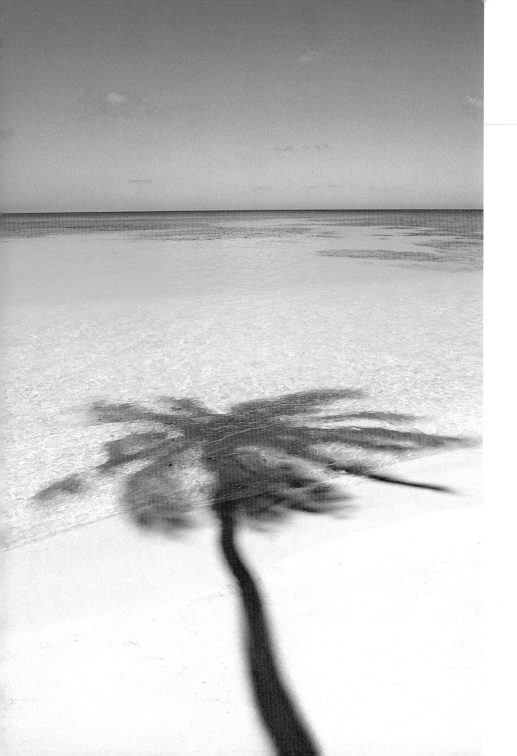

CLARITY

Sometimes the simplest things are the most effective.
I have spent days trying to capture the perfect moment,
only to discover it right at my feet. In the play of light
off a far away window, in the silhouette of a lone palm
tree or simply in the intense palette of ocean and sky
that Mother Nature dishes up every day.

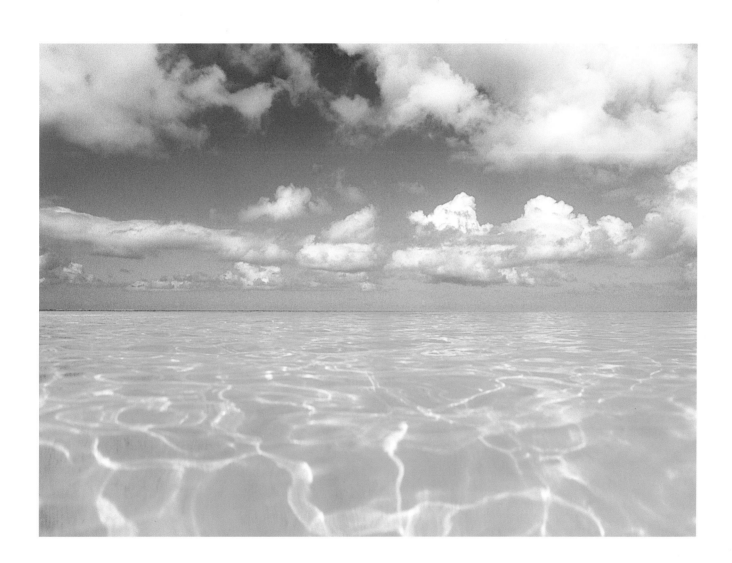

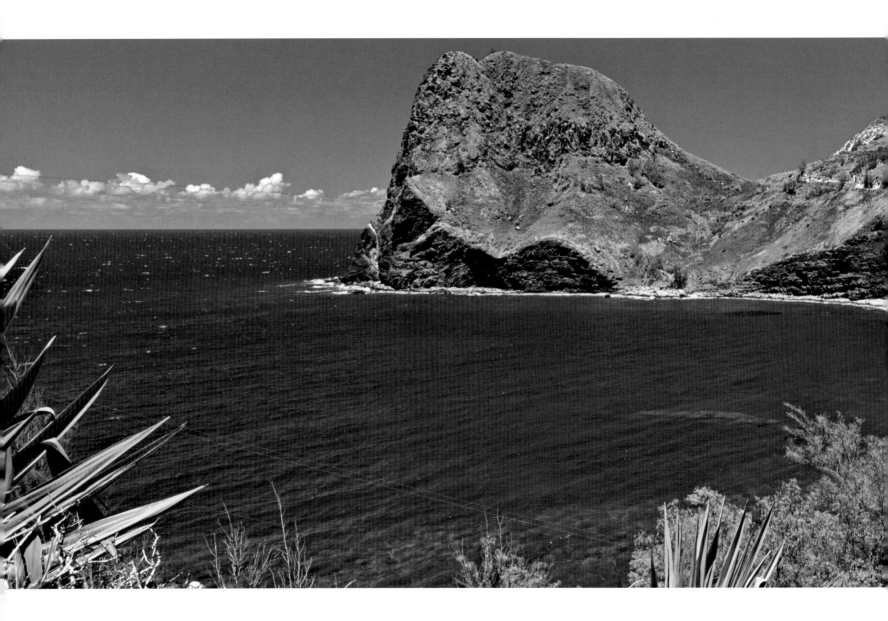

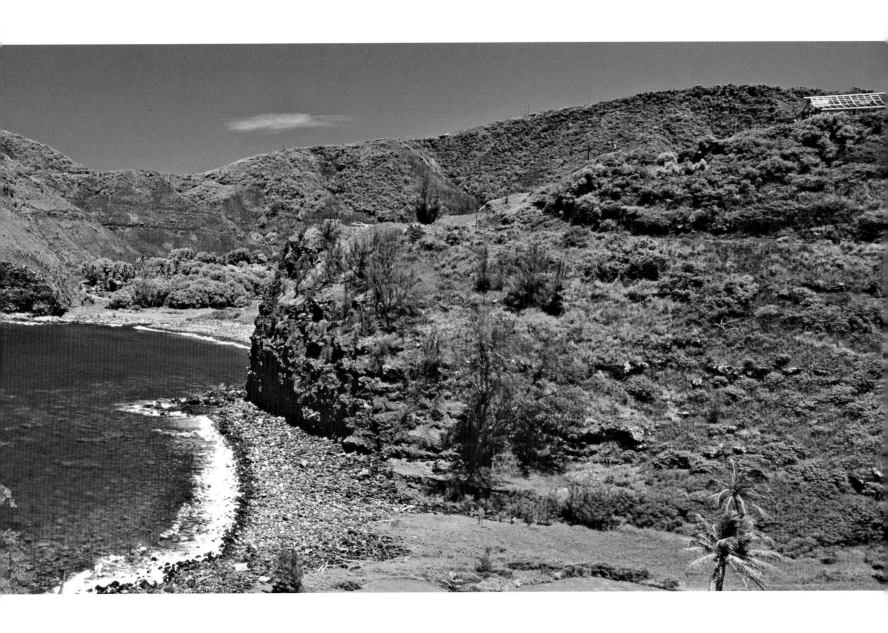

The dramatic head of Kahakuloa dominates the rocky coastline of West Maui

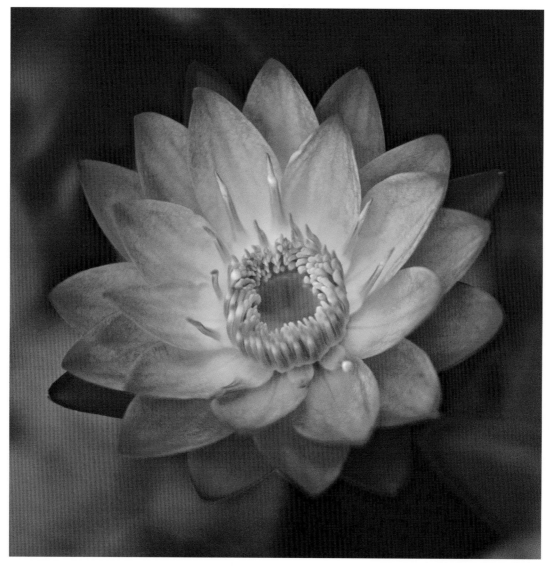

Water Lily

Opposite: The Wailua Falls, Hana

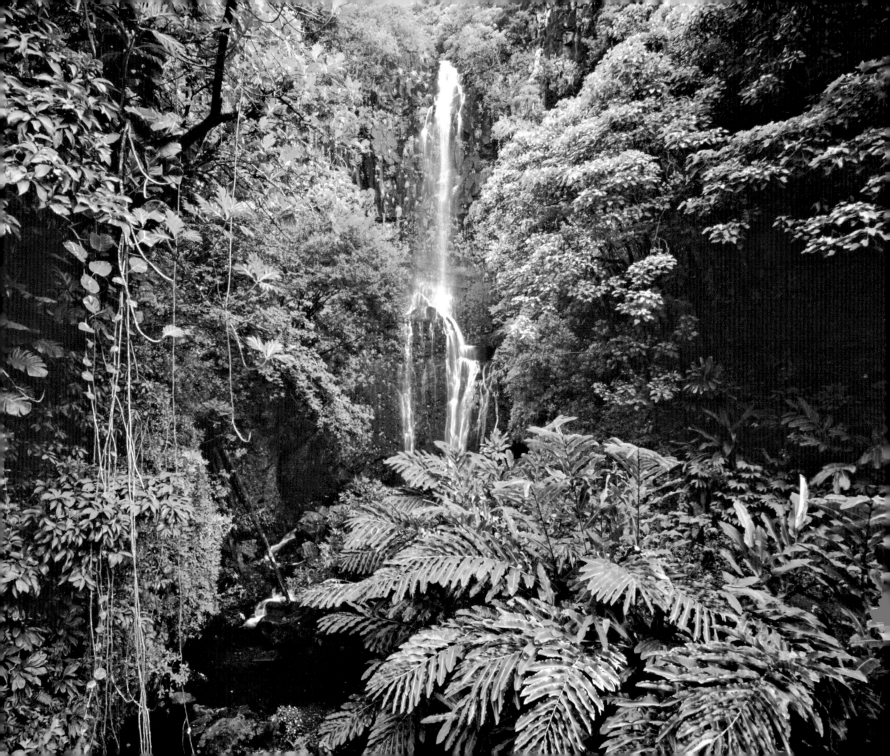

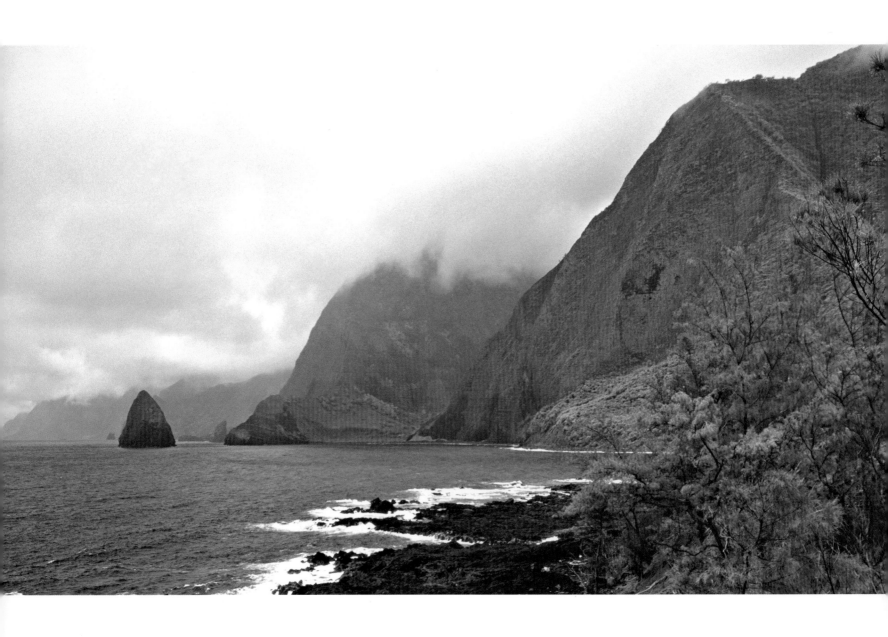

Sheer volcanic cliffs line the rugged coast of the Kalaupapa Peninsula, Molokai

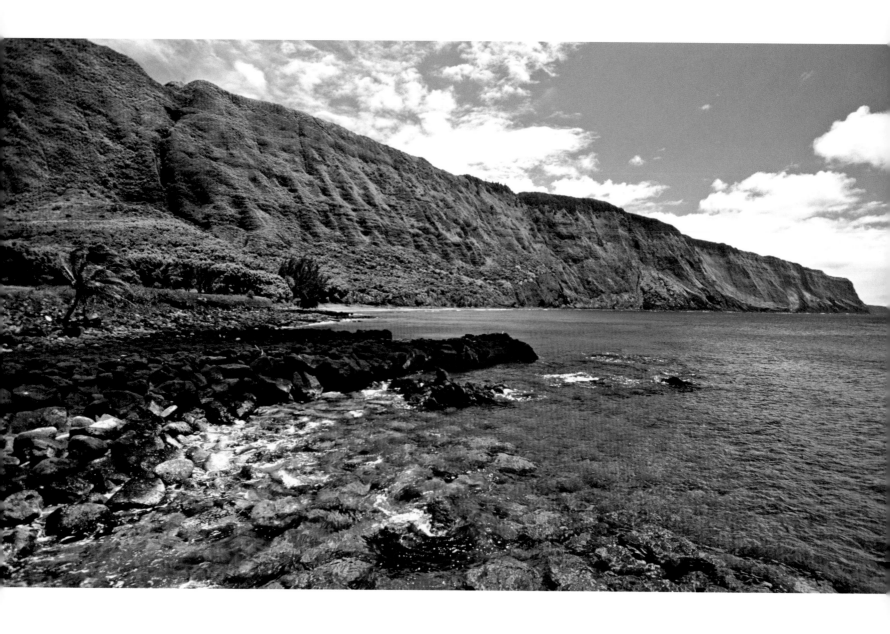

Millions of years of volcanic activity have carved the sheer cliffs
and outcrops of the Kalaupapa Peninsula, Molokai

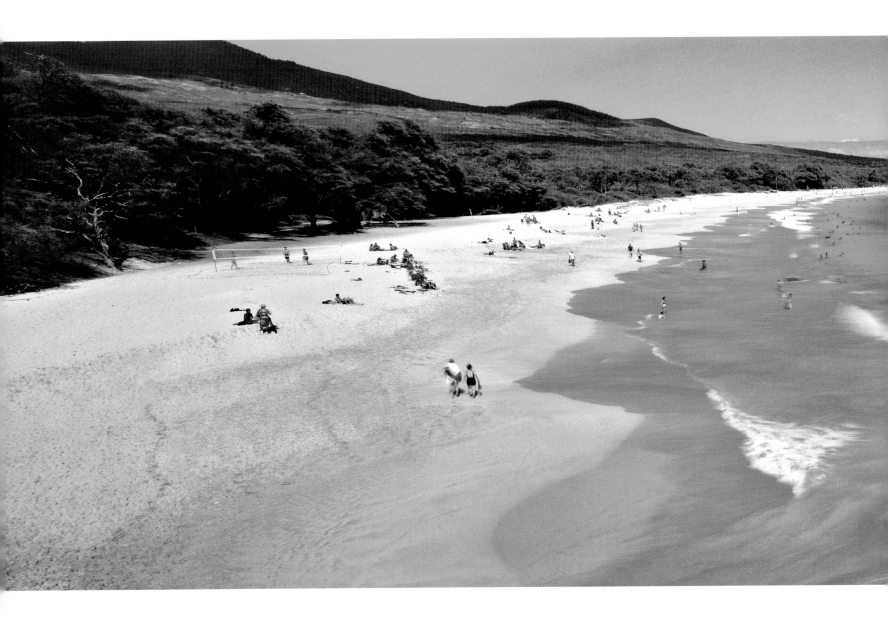

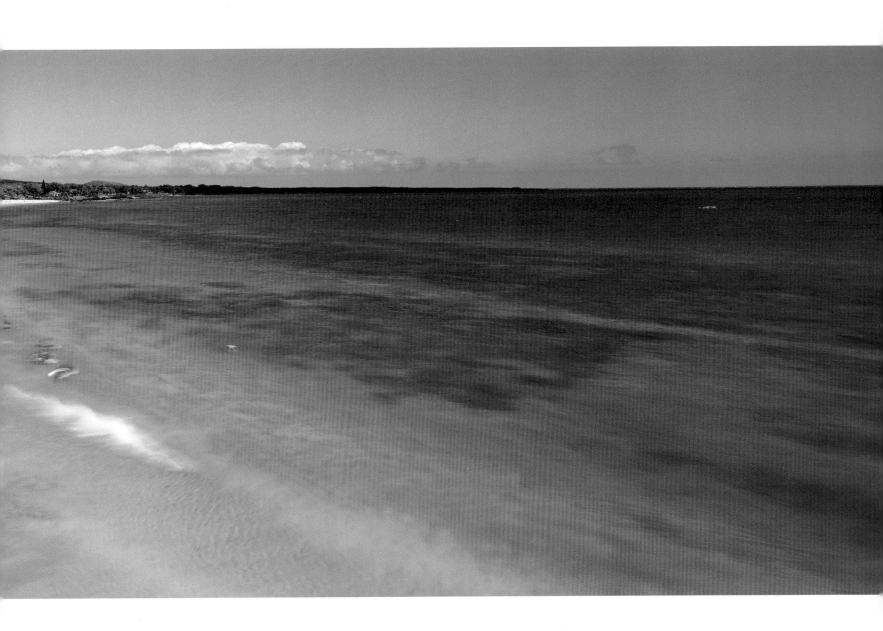

Big Beach, Makena

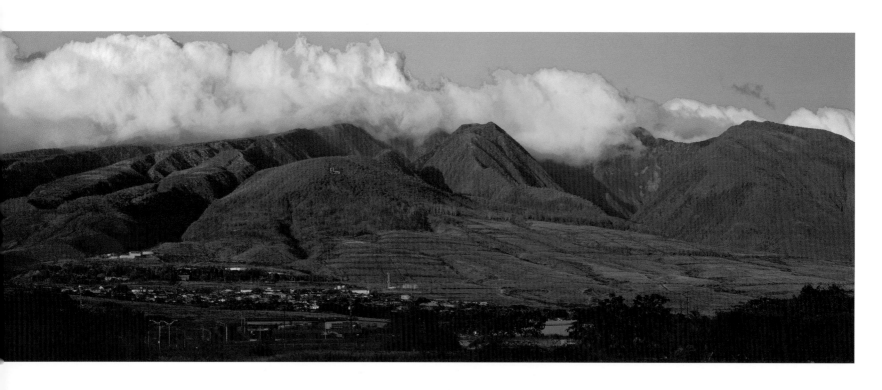

Late afternoon sun over the West Maui Mountains

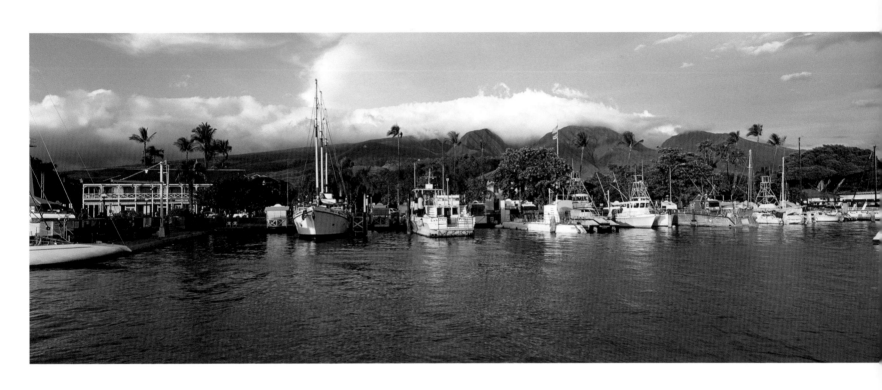

Twilight at Lahaina Harbour

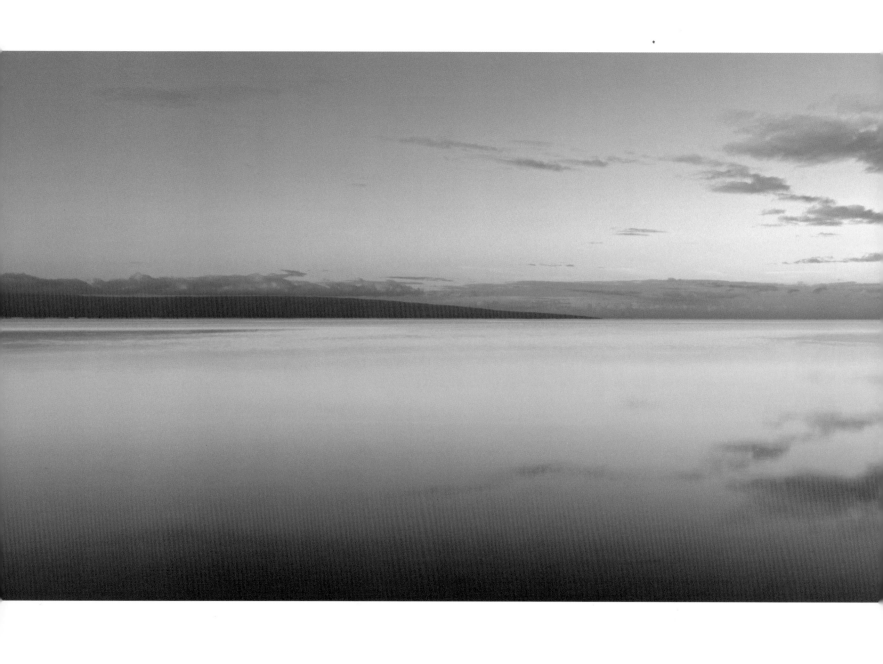

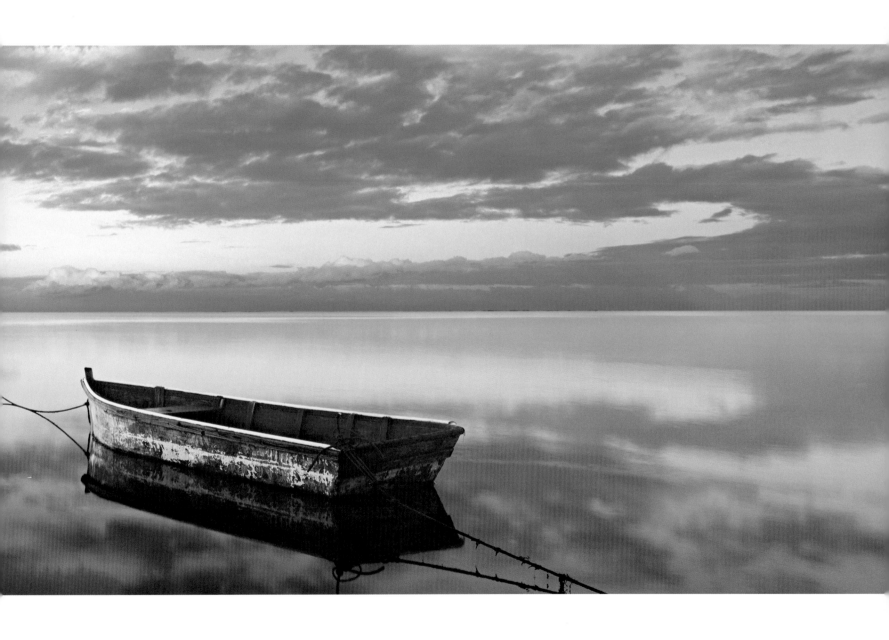

A moment before the world awakens, the distant mountains of Maui from Molokai's shore

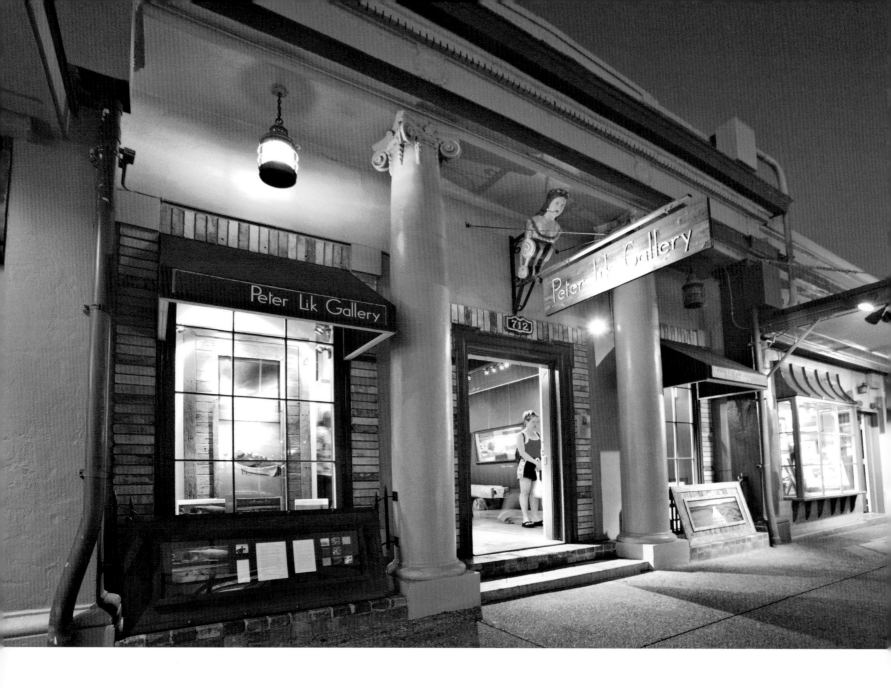

The world renowned Peter Lik Gallery Front Street, Lahaina

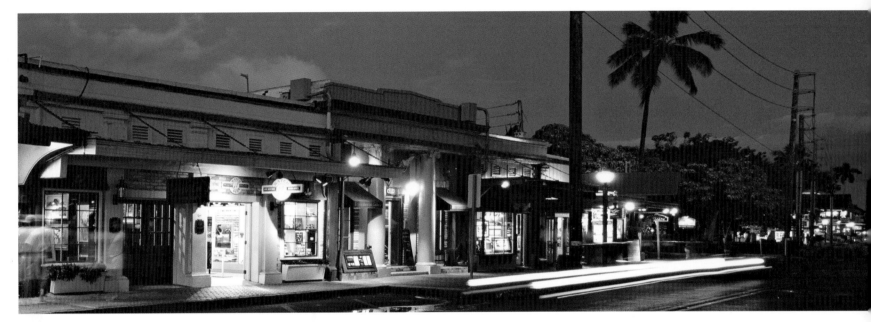

Front Street, Lahaina

COLONIAL LIFE

The sun-drenched town of Lahaina is the art capital of Hawaii. Once a traditional whaling village and now an international hub of galleries and collectors, it has retained much of its colonial charm. Nestled in the foothills of the West Maui Mountains and lapped by the gentle waves of the Auau Channel, its seaside tranquility made me feel immediately at home. Historical buildings line the picturesque main boulevard. The Peter Lik Gallery occupies the old Maui Bank, one of the few 19th century buildings still intact and undoubtedly one of the most beautiful buildings on Front Street.

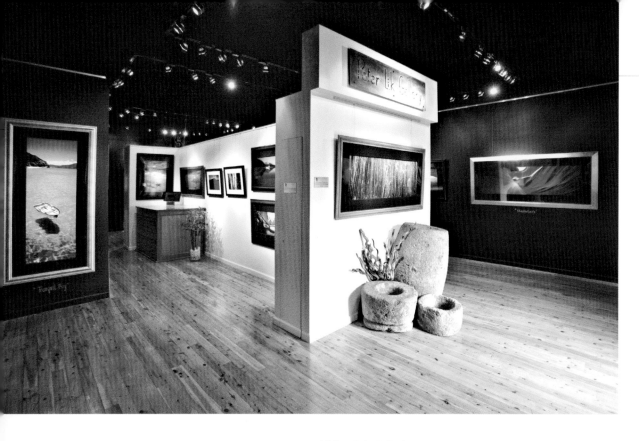

PETER LIK GALLERIES

USA

MAUI
712 Front Street
Maui, Hawaii 96761
808 661 6623

WAIKIKI
Space L118 & L121
Waikiki Beach Walk
Lewers Street
Honolulu. HI 96815

VENETIAN
#2071 Grand Canal Shoppes
3355 Las Vegas Blvd.
Las Vegas, Nevada 89109
702 309 8777

CAESARS PALACE
T-10 Forum Shops
3500 Las Vegas Blvd.
Las Vegas, Nevada 89109
702 836 3310

MANDALAY PLACE
#126 Mandalay Place
3930 Las Vegas Blvd.
Las Vegas, Nevada 89109
702 309 9888

AUSTRALIA

SYDNEY
Level 2 QVB
455 George Street, Sydney
NSW 2000 Australia
61 2 92690182

NOOSA
Shop 2, Seahaven
9 Hastings Street, Noosa Heads
QLD 4567 Australia
61 7 5474 8233

PORT DOUGLAS
19 Macrossan Street, Port Douglas
QLD 4871 Australia
61 7 4099 6050

CAIRNS
4 Shields Street, Cairns
QLD 4870 Australia
61 7 4031 8177

Lik's original design concept was to create a contemporary space that enhances the natural beauty of his imagery, and the galleries continue to evolve under his direction. Attracting a diverse mix of visitors and collectors, the galleries are a fitting environment in which to experience an extraordinary photographic collection.

Each gallery offers the highest level of framing professionalism available and fully insures each piece, delivered to your doorstep worldwide.

A team of experienced Art Consultants are on hand to guide the visitor through their journey, or they can simply relax and enjoy the gallery at their leisure.

PETER LIK - THE PHOTOGRAPHER

Born in Melbourne Australia in 1959, landscape photographer Peter Lik's unbounded passion and dedication to his craft have seen him achieve a remarkable success. Completely self-taught, his daring and determination have put him at the cutting edge of contemporary landscape photography.

An accredited Master of Photography, Lik's fascination with the lens began at an early age. His boyish curiosity and keen eye for detail set him on a journey of discovery that has endured into adulthood. Growing up within the confines of Melbourne's 'urban jungle', nurtured a respect and reverence for the wide-open spaces of the Australian landscape. Annual family pilgrimages to the picturesque Dandenong Ranges and the rugged coastline of the Great Ocean Road fuelled his love affair with the land. Often disappearing for hours on end with only his camera for company, early work from these childhood expeditions shows a mature and sensitive approach to composition. From the first image he ever captured - a delicate study of morning dew on a spider web - his natural ability was evident.

Over the next thirty years, Lik honed his craft through a painstaking process of trial and error. His body of work was nothing short of prolific and he experimented fearlessly, pushing the boundaries of traditional photographic techniques. Working his way through a procession of mundane jobs he never lost sight of his dreams, finally setting off on his first exploration of the USA in 1984 in an attempt to cure himself of the wanderlust that had plagued him for years. A chance meeting with fellow photographer and friend Allen Prier in Alaska, became a defining point in his life. He was introduced to the encompassing field of view of the large format panoramic camera, and was entranced. Some lighthearted words of advice from Prier - 'Go big or go home' – struck a chord. In the end Lik did both. Taking the ultimate leap of faith, he sold his van to purchase the camera and returned to Australia with nothing but a fierce determination to pursue a career in photography on his own terms.

The underlying secret to Lik's success is his enduring respect for the power of nature. He has a genuine connection with the land, and a commitment to preserving the 'spirit of place' in his images. His work displays a resonance more often seen on canvas than in the photographic medium, and his seductive images invite one to not merely observe a scene, but to be transported entirely.

Lik himself is the ultimate observer, and his works are a labor of love. Often waiting at remote and inhospitable locations for hours for the right light and conditions, he will return time and time again before being satisfied. He sees beauty in even the most mundane scene, and his gift is in creating images that encourage the viewer to search for it too. Believing the existence of the photographer is justified only by the quality of the work he produces, Lik's never ending quest for the indefinable 'perfect' image, and his voracious appetite for adventure propels him on.

Lik's raw and honest approach to photography has earned him a legion of fans throughout the world. His artistic achievements have gained him the respect of his peers, and the AIPP (Australian Institute of Professional Photography) has awarded him with their highest accolades. Although a formidable and driven businessman, he remains more comfortable behind the lens of his camera than a desk, and spends much of his time travelling.

AWARDS

peter lik Master Photographer AIPP

"BAMBOO"
Silver - 2004 QPPA Awards

2004	Australian Institute of Professional Photography Awards	Silver with distinction Silver Silver
2004	AIPP Nikon Qld Professional Photography Awards	Silver Silver
2003	Australian Institute of Professional Photography Awards	Silver with distinction Silver with distinction Silver Silver
2003	AIPP Nikon Qld Professional Photography Awards	Gold Silver with distinction Silver Silver
2002	Australian Institute of Professional Photography Awards	Silver with distinction Silver with distinction Silver Silver
2002	AIPP Nikon Qld Professional Photography Awards	Highest Scoring Landscape Print Silver
2001	Australian Institute of Professional Photography Awards	Gold Silver with distinction Silver
2000	Australian Institute of Professional Photography Awards	Silver Silver
2000	AIPP Canon Qld Professional Photography Awards	Highest Scoring Colour Print Gold Silver Silver Silver
1999	Australian Institute of Professional Photography Awards	Silver with distinction Silver
1999	AIPP Canon Qld Professional Photography Awards	Silver
1999	Fuji ACMP	Silver Honor of Recognition

MAUI - HAWAIIAN PARADISE

by Peter Lik

DESIGN

Cameron LeBherz

COPY

Tamara Wiltshire

ADDITIONAL PHOTOGRAPHY

Jesse Donovan - Lightning

Nikki Venter - Plumeria

PETER LIK PUBLISHING

HEAD OFFICE USA

4250 Wagon Trail
Las Vegas 89118
Nevada USA

HEAD OFFICE AUSTRALIA

39 Moffat Street
PO Box 2529 Cairns
Queensland 4870 Australia

ISBN 187658517-X

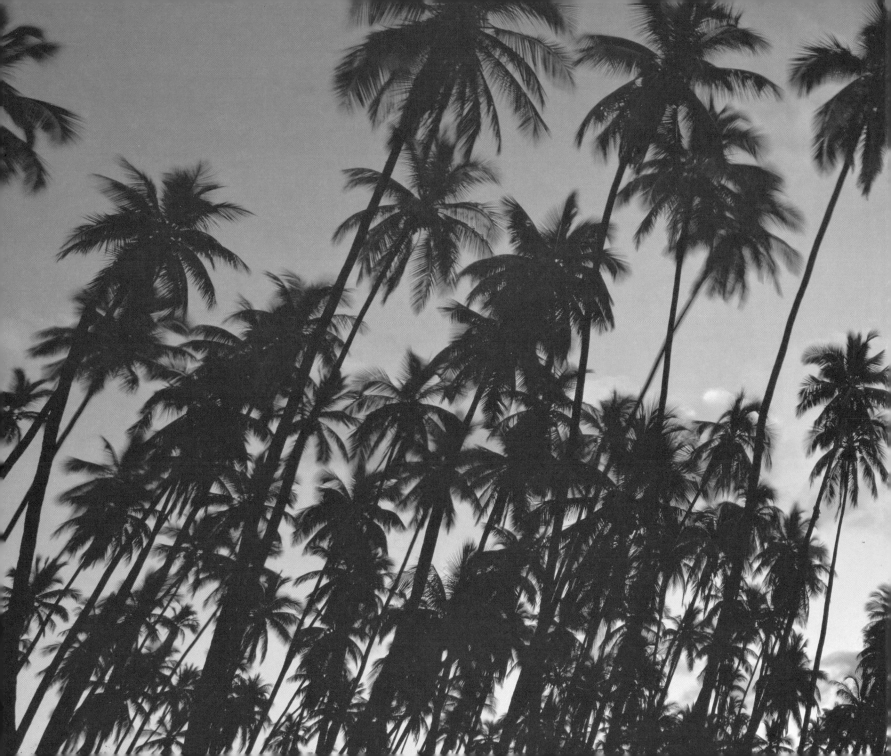